The Painter's Corner

LANDSCAPE

BARRON'S

LANDSCAPE

© Copyright 2004 of the English translation by Barron's Educational Series, Inc., for the United States, its territories and possessions, and Canada.

Original title of the book in Spanish: *El rincón del pintor: Paisaje*
© Copyright Parramón Ediciones, S.A., 2003—World Rights
Published by Parramón Ediciones, S.A., Barcelona, Spain

Author: Parramón's Editorial Team
Text and Coordination: Josep Asunción
Exercises: Josep Asunción, Vicenç Ballestar, Ricardo Bellido, Mercedes Gaspar, Ramon Massana, and Pilar Valeriano
Book Design: Joseph Guasch
Photographs: Nos & Soto

Translation by Michael Brunelle and Beatriz Cortabarria

All inquiries should be addressed to:
Barron's Educational Series, Inc.
250 Wireless Boulevard
Hauppauge, New York 11788
http://www.barronseduc.com

International Standard Book No.: 0-7641-5705-1

Library of Congress Catalog Card No.: 2003106931

Printed in Spain
9 8 7 6 5 4 3 2 1

Table of Contents

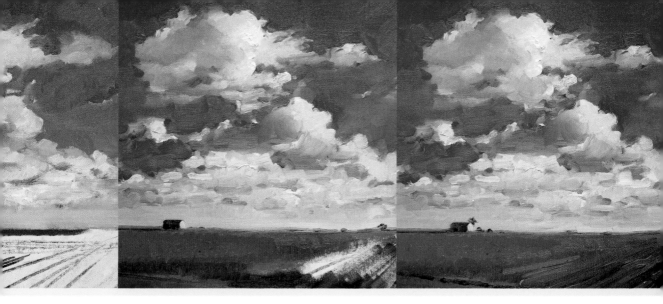

Introduction

L andscape painting is the most complete of all genres. It combines all the technical characteristics: perspective, light, color, and representation of volumes and textures, which only appear partially in the other genres. Much like a symphony, landscape painting incorporates many elements of the arts that combine to achieve a goal common to all of them: the aesthetic depiction of space. A landscape is also the place where the artist meets nature. In a 1982 interview, Sisley responded: "Which painters do I like? All of those who have expressed their love for nature, and have felt it strongly." And it is true that since early times nature has been the source of inspiration for many artists, as well as being the best learning environment for the aspiring painter through observation and analysis of anything in nature that attracts him or her.

Renaissance artists studied landscapes, Romantic artists experienced them, Realist artists depicted them, Impressionists analyzed them, Postimpressionists interpreted them, Fauvist and Expressionist artists expressed them, cubists reformulated them, and Surrealists personalized them. All of this is possible because a landscape welcomes each of these styles and more. That is why this book is an open door to the artistic experience of a genre that welcomes many interpretations. Monet said: "I only know that I do what I think to express what I feel in the presence of nature, and that often, to achieve the representation of what I truly feel, I forget completely the most elemental rules of painting, if they ever existed at all." But in this book, those "rules," that method, is also explained so the reader can follow the development of different landscapes and different subjects and techniques step-by-step. The first part is devoted to theory. It offers the formative basis that serves as an introduction for the second part, which is entirely devoted to practice and allows the artist to experience landscape painting more concretely.

Landscapes in Painting

The appearance of the landscape as an art genre is tied to the interest of the artist in becoming acquainted with nature and in establishing an artistic relationship with it.

Through history, art has fulfilled many diverse functions. In their origins, the first cave paintings formed part of the magical world of prehistoric people: painting a deer was in some way like hunting it. During Greek and Roman classical periods, paintings told the stories of people's achievements or of their mythological gods. In the Middle Ages, painting was mainly at the service of religion, fulfilling a graphic and formative function in an illiterate society. Up to this point in history, landscapes were practically nonexistent and showed up only sporadically as backdrops for the true purpose of the work: the story of the lives of people and the gods.

Landscapes become the artistic ground par excellence for experimentation.

During the Renaissance, the first major historic change took place. Artists began to take charge of their own creations, and based on the aesthetics of Greek and Roman classicism, they adopted a new trend that led them to the discovery of nature. Landscapes were for the first time a subject of study, and so were birds in flight and human anatomy. Perspective made its appearance as a way of understanding depth, and with it came the true and faithful representation of landscapes.

The second great change emerged as a consequence of the invention of photography. At the end of the nineteenth century, painters found themselves propelled to explore new ground not yet discovered by photography. The first Impressionist painters already began to perceive, color, form, texture, space, and line in a more subjective and personal manner. During the Impressionist movement and in other subsequent styles, landscapes played a vital role and became the artistic ground par excellence for experimentation.

Giovanni Fattori, Storm, 1880–1890. Galleria de Arte Moderna (Florence, Italy). This expressive painting by Fattori successfully reflects the effect of the wind on the landscape. The rough sea draws the eye of the viewer and becomes the main subject of the representation.

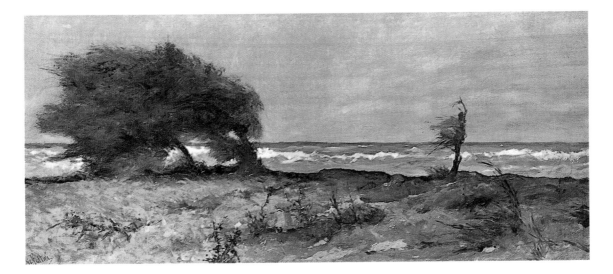

What Is a Landscape?

Everybody has a clear idea of what a landscape is. At least we can immediately recall the numerous images stored in our brain, all of them related to one experience: the realization of open spaces. This type of experience normally occurs from contact with nature. In this realization, people somehow feel connected to nature, forming part of it.

The artistic landscape evokes a real feeling for the space. This is why it deals with such subjects as vastness, seclusion, depth, emptiness, escape, surface, density, flatness, and abruptness, whether it is through the representation of a river, a harvested field, a snowy mountain, a cave, a valley, or a garden. These subjects are resolved on the canvas through color, light, texture, form, and most important perspective, which is the visual tool for understanding the space within the landscape. This is why no landscape is without perspective.

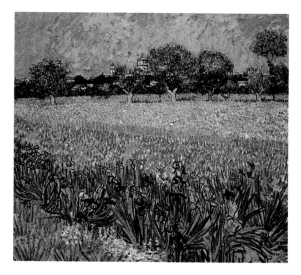

Vincent van Gogh. View of Arles, 1888. Rijksmuseum (Amsterdam, Netherlands). Van Gogh was a painter who had the deepest feeling for landscapes in terms of artistic experience because he painted outdoors, always searching the purest light and the most expressive color.

Aureliano Beruete, Banks of the Avia River, 1884. Museo Provincial de Bellas Artes (Seville, Spain). In every landscape, the true subject is the space. In this painting, a beautiful dialog exists in three planes: the water, the riverbank, and the sky.

THE REQUIREMENTS OF A LANDSCAPE
The first requirement is the subject matter. Although the landscape is often the backdrop for work or idle scenes, for animals, epic narrative, and so on, a painting is considered a landscape only if that scene does not cancel out the space, the characters forming an integral part of it in the narrative aspect. The second requirement is the visual field. A landscape may include different spaces, ranging from the corner of a garden to the panoramic view from a mountain. When working with small spaces, the artist runs the risk of crossing from one genre to another, like the representation of a still life, especially if the focus is on only one element and not on the overall space.

The First Landscapes in History

Pre-Renaissance paintings were the precursors of landscapes. Until landscape painting established itself as a genre during the Renaissance, landscapes were just the background for portraits or the backdrops for narrative representations. In either case, they fulfilled a symbolic function, not a real one, because they existed for the purpose of the story. Often, the same templates were used to represent vegetation or mountains, and their size was varied according to the importance of the figure, which was the real purpose of the painting.

Gherardo Starnina, The Tebaida (detail), *c. 1370. Palazzo Pubblico (Sienna, Italy). The representation of landscapes continued to have a symbolic character up to the Renaissance. The lack of proportion and the simplification of depth on a single plane in this detail are proof of this.*

Giorgione, The Storm, *1500. Galleria della Accademia (Venice, Italy). Many people consider this the first landscape in the history of western art. The characters are separated in the composition to show the true theme: a storm.*

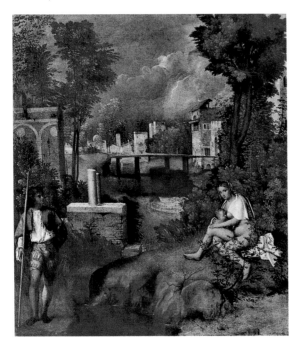

Ambrogio Lorenzetti, The Effects of Good Government *(detail), 1338–1340, Palazzo Pubblico (Sienna, Italy). This fresco is considered a good precursor of the landscape genre. Although the landscape is not the main theme of the painting—only a detail of the overall work is illustrated—the artist shows an unusual interest in the accuracy of the spatial arrangement compared with other paintings created at the same time.*

Baroque and Classical Scenic Landscapes

Post-Renaissance landscapes observe the same classical canons in terms of light and spatial distribution. Space is not yet represented detached from the story, which is the painting's real purpose. This is why, amid spectacular landscapes that could have artistic autonomy by themselves, there are mythological scenes or idealized architecture taken from Greek or Roman classical themes. If the arrangement of classical landscapes was based on balance and symmetry, Baroque ones are more dynamic and give way to the unknown and unpredictable. Every Classical and Baroque landscape has special light and surreal tones created by the gloomy, and dramatic, almost theatrical effect of trees, clouds, and figures. The landscapes of the late Baroque period have a softer light and produce a gentle and inviting melancholy on the viewer.

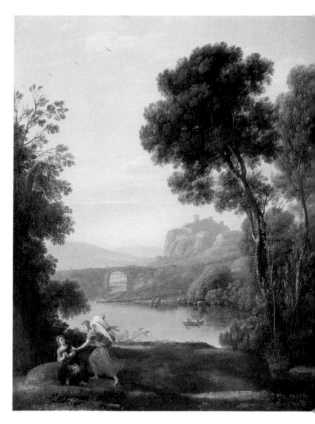

Claude Lorrain, Landscape with an Angel Appearing to Agar, *1668. The National Gallery (London). Because of his exquisite treatment of light in the landscape, Claude Lorrain was one artist who had a great influence on landscape painters after the seventeenth century.*

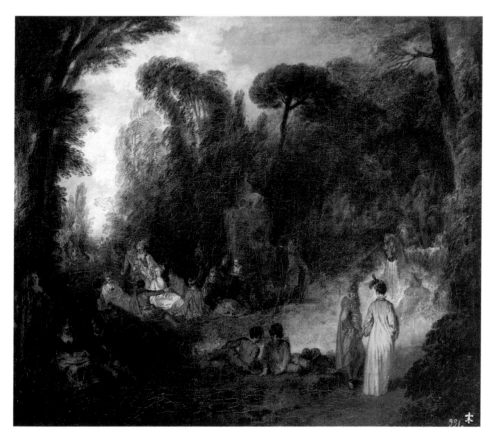

Antoine Watteau, Celebration in a Park, *1710. Museo del Prado (Madrid). Baroque landscapes by Watteau have a dense, warm atmosphere that resembles gloominess, although the themes always evoke an idealized landscape, which works better as a backdrop than a true subject.*

The Spiritual Experience of Landscapes from the Romantic and Realist Periods

During the Romantic period, nature contained Truth and Beauty in the most transcendental sense of the terms. Romantic artists, such as Constable, Turner, and Friedrich, resorted to nature in search of spiritual experiences that connected them with their creative potential to feel at one with creation. In this frame of mind, it is logical that landscapes, for the first time in the history of art, acquired their fair autonomy, and finally appeared devoid of narrative and myths, displaying the full creative and destructive potential of the forces of nature.

Realism introduced a sense of the ordinary to landscapes, trying to eliminate dramatic connotations and exaggerations, to follow a simple order: painting only what can be seen. Realist paintings have a solid compositional construction and a color unity achieved through extreme refining of color to reality.

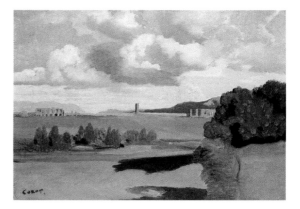

Jean-Baptiste Camille Corot. Roman Countryside with Clouds, *1826. The National Gallery (London). Realist paintings by Corot preceded Impressionism because of the interest that he maintained in the rigorous and faithful representation of light and landscape spaces.*

TURNER

The most peculiar contribution of this British artist comes as a result of his ability to represent landscapes as formal spiritual experiences. Turner allowed himself to diffuse space and objects, reducing the landscape to simple color masses of great artistic and emotional density. His paintings are considered the historic predecessors of Impressionism, Expressionism, and abstraction. With Turner, landscapes are like open doors to works of art that transcend the object represented.

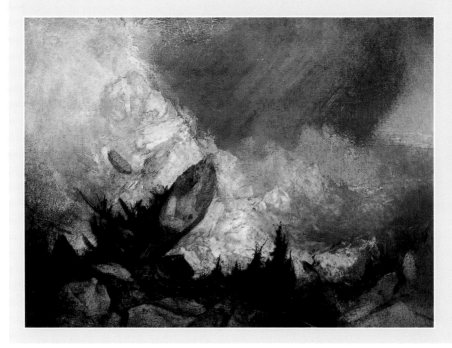

William Turner, The Avalanche, *1810. Tate Gallery (London). The destructive power of nature was one of the most recurrent themes in the work of Turner and other British and German Romantic painters. Here, the landscape appears as a spectacle of life and of untamable forces.*

Impressionism and the Consolidation of Landscapes

The invention of photography and certain scientific discoveries related to color pressed painters of the last quarter of the nineteenth century to explore new methods for representing realistic scenes. Thanks to this audacity and the leadership of artists who painted outdoors motivated by the conviction that this was the only way to capture the true "impression" of landscapes, paintings took a spectacular new course.

The landscape became more a subject for scientific study than for artistic representation. Painters analyzed the mechanics of color in shadows discovering the presence of blue and its complementary, the atmospheric effect on the forms (by blending their outlines), and the use of more appropriate art techniques, like the application of loose brush strokes, and a brighter color palette.

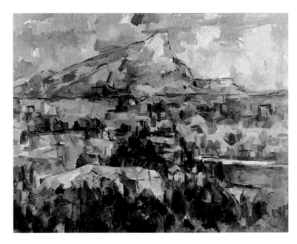

Paul Cézanne, The Mountain of Sainte-Victoire, 1904. Philadelphia Museum of Art (Philadelphia). Cézanne drew and painted these mountains near Aix-en-Provence (France) on many occasions, attracted by their ever changing volumes, which depended on the light and the atmosphere of the moment. By the Impressionist period, the landscape had become a subject for study.

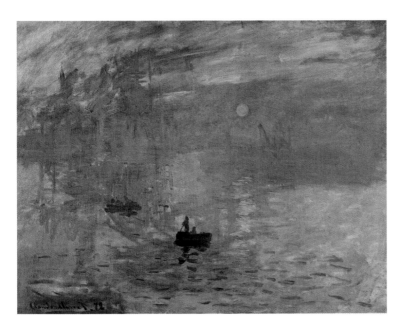

MONET

Claude Monet was one of the most important Impressionist landscapists. He had a farm in Giverny (France) where he went into seclusion to study the effect of light on flowers, trees, and his water lily pond. His garden was a world full of scenes that inspired him to continue painting until the final days of his life. He is the one who came up with the term *impression* as the conceptual basis for the Impressionist style.

Claude Monet, Impression: Sunrise, 1874. Musée Marmottan (Paris). Many believe that this landscape is the first Impressionist painting in history. It displays the general guidelines of the movement: the importance of the visual impression, the harmony of color, and the constructive value of a fresh and natural brush stroke.

Postimpressionist Landscapes

Impressionism was the starting point for all the painters who created personal styles and avant-garde movements during the transitional period from the nineteenth to the twentieth century. Many impressionists observed the rules of the style until the end, but others relied on the discoveries of the movement to further explore freedom of expression. The most representative were Van Gogh, Gauguin, and Cézanne, who, working independently and without forming a group, developed three personal, different styles that had in common the search for nature's purity.

Van Gogh redefined realism in landscapes, and in his pursuit for maximum color representation opened the doors to Expressionism. Gauguin created a symbolic and ornamental interpretation of impressionism by using saturated, primitive colors in his landscapes. Cézanne painted form and space with blocks of color using a more sober, naturalistic palette.

Van Gogh, Wheat Field and Cypress Trees, *1889. The National Gallery (London). The main characteristic of Van Gogh's landscapes is the expressive treatment of forms and spaces painted with freedom of color and single and vigorous brush strokes.*

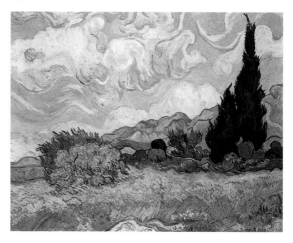

SUBJECTIVE COLOR
Van Gogh used to say, "Instead of trying to reproduce exactly what I have before my eyes, I use color more arbitrarily to force myself to self-expression." According to Van Gogh's free spirit, color is to be shown at its best, sometimes with passion and exaggeration.

Paul Gauguin, Landscape in Brittany, *1889. Nationalmuseum (Stockholm). Gauguin's radiant and intense colors responded to his desire to capture the purity of the landscape in its wildest form.*

IN SEARCH OF THE PUREST LANDSCAPE
Van Gogh, Gauguin, and Cézanne traveled in search of landscapes. Their interest in nature in its purest form inspired them to establish their homes and studios in diverse locations, attracted mainly by the light of the area and the play of volumes and colors that it created. Van Gogh painted in several regions of France, Cézanne in Provence, and Gauguin in Tahiti. The Impressionist spirit had a far-reaching effect in these three great painters.

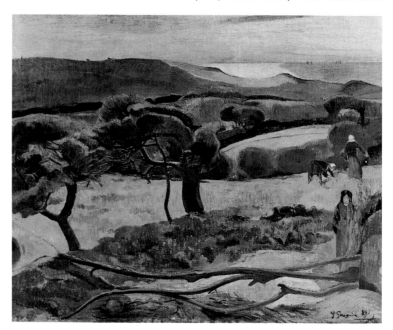

Landscapes in the Twentieth Century

During the first third of the twentieth century, Europe experienced a true explosion of creativity in the field of visual arts. Painters who began their careers as Impressionists, like Picasso, Matisse, Mondrian, Schiele, Munch, and Miró, opened new paths that had been unthinkable until then. Fauvism, Cubism, Futurism, Expressionism, Surrealism, neo-plasticism, and other movements were born as a result of the spirit of exploration and a desire to break new ground.

Some of these movements found landscape painting to be the ideal genre for experimenting as much as needed, because it was a fertile field for their predecessors and for the challenges that it presented in terms of space, form, and color. Much research was devoted to the manipulation of space and form, and to their rhythm and structure.

Color surpassed atmospheric painting and was applied with absolute freedom in more personalized schemes. After these unprecedented innovative years, the inroads were made for artists to follow for the rest of the century.

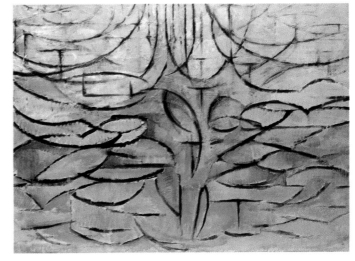

Piet Mondrian, Composition with Trees II, 1912–1913. Gemeentemuseum (The Hague, Netherlands). Mondrian developed a rich body of research that was rooted in the genre of landscapes, where its main focus was the study of space.

Egon Schiele, Old Houses in Krumau, 1914. Graphische Sammlung Albertina (Vienna, Austria). Schiele treated his spaces as if they were Expressionist landscapes.

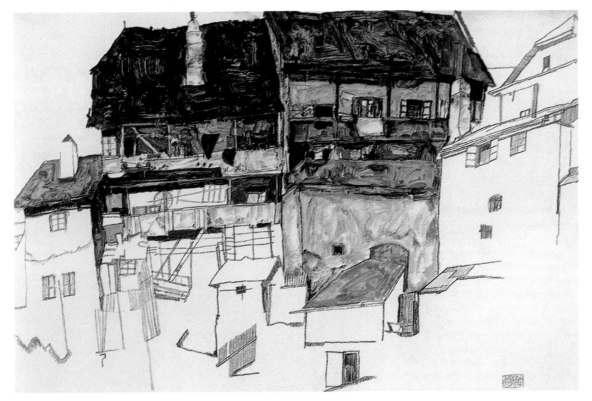

Landscape Subjects

Of all the subjects that can be considered landscapes, the ones presented in this book belong to the generic group of natural rural landscapes. Seascapes and urban landscapes are equally important and deserve to be studied separately.

Because landscape painting is an extraordinarily vast genre, it is a good idea to divide it into groups to allow for the study of each variation, because every landscape offers numerous approaches. A landscape devoted to the representation of a sowed field will require careful attention to texture, whereas another that includes a view of a mountain range in the distance will involve an analysis of blue tones, which will provide the atmospheric effect of that particular scenery.

The first classification that can be made of a landscape is related to form, and is directly related to the field of vision and space that the artist wants to express. We can find landscapes that are short, medium, or long range; landscapes that have one or several points of interest; landscapes that highlight the form and texture of the terrain, or the atmosphere and light; and landscapes that draw the viewer in or project the spectator out visually into the open space. Each effect requires a specific treatment, and by using paint, line, color, form, and texture correctly, the desired result can be achieved.

◆

Each type of landscape offers numerous approaches.

◆

The second classification is related to the elements that appear in the landscape, and it consists of organizing the narrative of the painting. Three main groups can be included here: paintings depicting land, water, or sky scenes, most commonly known as landscapes, seascapes, and skyscapes. Each group has many variables; they can be rural scenes, everyday life, river and forest views, cloudy skies, and so on.

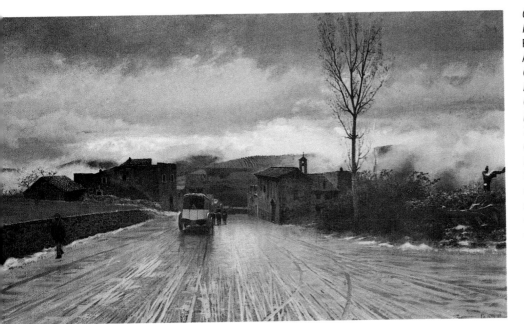

Giuseppe de Nittis, The Passage of the Apenines, 1867. Galleria Nazionale de Capodimonte (Naples, Italy). The effect of the car tires on the road, together with the contrasting light and the gray atmosphere, convey the mood of the painting: the cold and humid winter.

Panoramic Landscapes

A panoramic landscape portrays a global image, which captured from far away suggests an extensive visual trip along and across the surface of the painting. Distancing oneself from the object is important to be able to achieve a wide-angle vision, because the main characteristic of this type of landscape is spatial depth. Panoramic landscapes are the most recurrent of the genre because they successfully express the feeling of open space, and this leads to visual expansion. The painting can represent a distance of middle, long, and very long range, but it could never represent a short distance. This type of landscape is also ideal for depicting grandiose and dramatic scenes, like an evening mood or sunsets, exotic, or expressive views. When nature is presented as a spectacle with all its force, the wide view is chosen so the spectator can mentally become part of the beauty.

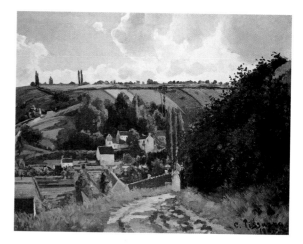

Jean-Baptiste Camille Pissarro, Hill in Pontoise, 1867. The National Gallery of Art (Washington, D.C.). Although this panoramic view contains many elements, it does not focus on any one in particular; instead it offers a visual journey among groves, houses, and crop fields.

READING THE LANDSCAPE

Panoramic landscapes depict large spaces; therefore, the visual field contains many elements without focusing on any one in particular. It could be said that there are landscapes within the landscape. Through formatting and setting, which is the way to approach this type of painting, the eye of the spectator is directed through a journey of the small landscapes that are included within the larger one. That journey, also known as visual reading, can be achieved through depth, winding elements, wide view, and so on, and through these elements the creative experience of the painting can unfold.

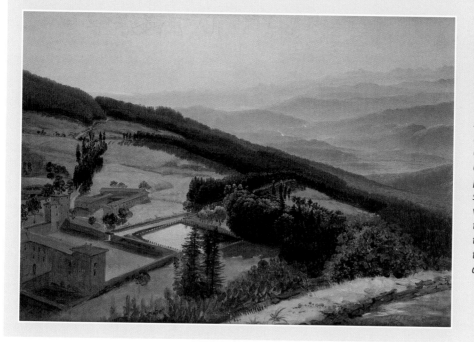

Louis Gauffer, Scenery of Vallombrosa, 1890–1891. Musée Fabre (Montpellier, France). This spectacular landscape contains many different distant planes within a single view. Its visual force lies on the journey from the closest plane to the most distant one.

Centered Landscapes

When the eye of the viewer focuses on one particular element of the landscape's visual journey and goes back to that same point repeatedly, it is because the artist's objective was to highlight that particular point, in many cases making it the absolute protagonist of the painting. A curve in the road, a fallen tree, a house, or a clearing in the forest can become the focal point that defines the entire image. In terms of the compositional structure of the painting, the chosen element is at the geometric center of the canvas. It does not even need to be isolated from the rest of the objects; it can occupy any place within the representation, and it is usually well integrated within the rest of the scenery. The size of the main focal point is also relevant. Although these elements are normally located closest to the painter, any figure placed in the distance can also act as the focal point as long as it captures the attention of the viewer completely.

Giovanni Fattori, The Sump House of Livorno, *1865–1867. Private collection. An isolated house like the one in this example is ideal for a centered landscape because it suggests strength and solitude.*

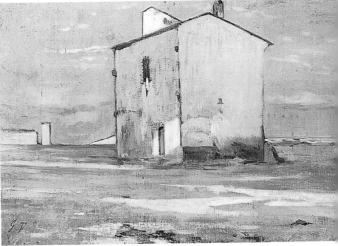

Gustave Courbet, Waterfall, *c. 1864. Private collection. A composition that is clearly centered, where the waterfall even acts as an axis, attracting the full attention of the viewer.*

John Sell Cotman, Fallen Gate, *1806. British Museum (London). When the eye of the artist focuses on a particular detail, we can say that the landscape is centered, although compositionally, this detail may be displaced or may not be completely isolated visually, as is the case in this landscape.*

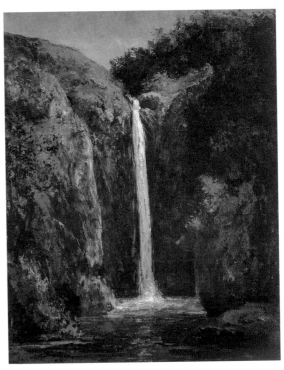

Enveloping Landscapes

Not every landscape provides the same visual feeling of openness. Some landscapes achieve the opposite effect, inviting the viewer to go deeper into the thicket or to rest in a corner of the forest or in the shade. These are like natural environments that visually surround or absorb the spectator. They produce a nearly tangible feeling of the space as a result of the treatment given to the textures and achieved through chiaroscuro. Often, the person contemplating this type of landscape feels a part of it, experiencing even its freshness, moisture, or sounds.

Contrary to panoramic landscapes where the light comes from the sky and bathes the scenery evenly, here it appears filtered through the clearings in the vegetation. This phenomenon alters the perception of space completely because of the changes in the quality of the light. This characteristic makes light appear more diffused or in more contrast, or with many forms and different colors, depending on how it is depicted in the representation.

Jean-Baptiste Camille Corot (1796–1875). The Fields at Fountainebleau. *Bristol City Museum and Art Gallery (Bristol, Great Britain). In most of the enveloping landscapes, the space is somber and dark because light is placed outside of it. This reinforces the idea of a natural interior.*

Gustav Klimt, Birch Forest, *1903. Wolfgang Gurlitt Museum (Vienna, Austria). The textures that Klimt introduces in this painting, in which there is hardly any chiaroscuro, cause the space to come closer to the viewer, making it almost tangible, as if the spectator were walking on this ground and touching the tree trunks.*

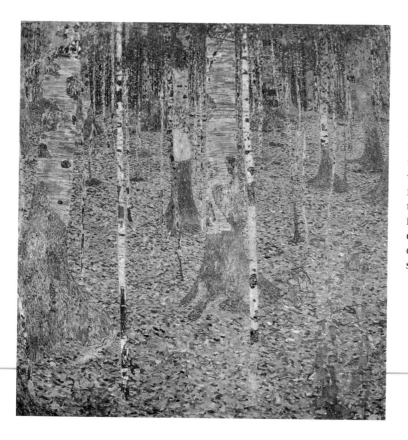

COLOR AND TEXTURE
Because vegetation is the most common element in these landscapes, texture and color are the tools typically used to represent them. Perspective, on the other hand, is not used as much. Lines shape the vegetation as they are strategically combined with color. The final visual feeling has to be tangible—that is, it must evoke the same feeling that a person would experience when walking on dry leaves or resting in a cool shady spot.

Topographical Landscapes

Objects that are not flat are three-dimensional. They have length, width, and height, which is to say they have volume. One way of seeing a landscape is through its volume, like a giant relief that is more or less pronounced. This type of landscape is called a topographical landscape and responds to a sculptural view dictated by the relief of the terrain. In this sense, landscapes resemble the human body, as pointed out by the notable art critic John Ruskin (1819–1900): "Mountains are to the other parts of the Earth's body, what the violent muscular action is to the human body: the muscles and tendons of the mountains get tense with strong and convulsive energy, full of expression, passion, and strength. Valleys and small hills are like the muscles that idle from movement effortlessly, resting behind the lines of its beauty, although governing those lines through each ripple of motion. . . . Mountains are the Earth's bones."

Paul Cézanne, Quarry in Bibémus, *1898–1900. Folkwang Museum (Essen, Germany). Cézanne painted large landscapes by modeling the topographical elements of the terrain with color. This view of the steep walls of a quarry suggests an abstract sculptural relief.*

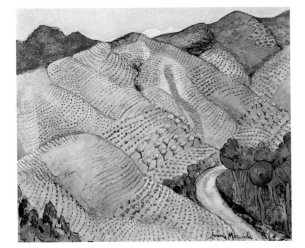

Jaume Mercadé (1887–1967). Priorat. Private collection. The rows of vineyards in this landscape are reminiscent of technical drawings for topographical maps.*

FORM IN LANDSCAPES
Of all the types of landscapes, topographical landscapes devote more attention to technical aspects, pushing color, atmosphere, or texture to a second plane. *Modeling* is by definition the technique that defines forms based on their volume.

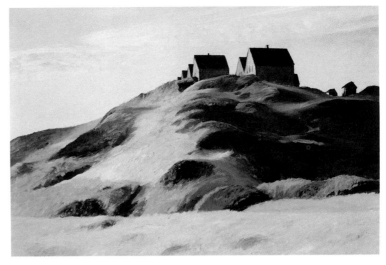

Edward Hopper, Corn Hill, *1930. Marion Koogler McNay Art Museum (San Antonio, Texas). In this topographical landscape, the modeling of the terrain's surface has been created through chiaroscuro and reinforced by intense, clear light.*

Rural Landscapes

Through history, people from the most urban cultures have evoked nature in their art in response to their need to compensate for the limitations of life in the city. Baroque landscape artists represented Citerea, the lost paradise. Romantic painters depicted the most subliminal visions of nature with all its destructive power: avalanches, storms, and the abyss. Finally, Impressionists searched for light and landscape scenes in their purest form, a pursuit that inspired Gauguin and Van Gogh to travel through Provence and Brittany, and that led the former to exotic lands in Tahiti.

A landscape is considered rural when its main focus is the mountains or the fields. Rural themes can also include farmland, harvested fields, or country villages, with people, animals, wagons or architectural features, as long as these elements do not become the focal point, but a complement, forming a perfect, integral part of the painting.

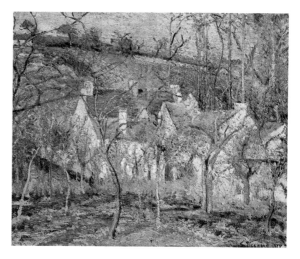

Camille Pissarro, Red Roofs, *1877. Musée du Louvre (Paris). Villages are one of the most common rural themes. The vegetation is perfectly integrated with the buildings, which depict life in the country.*

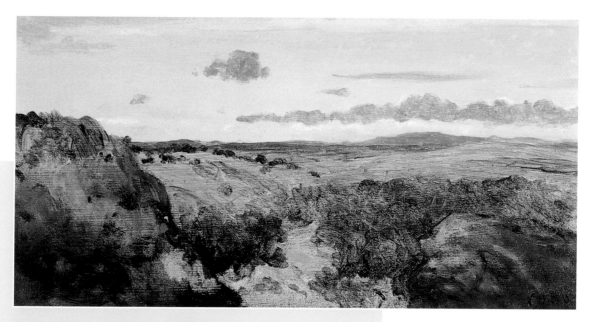

RURAL THEMES: PAINTING SCHOOL
Pablo Picasso used to say, "Everything I know I learned at Horta de Ebro." His stay during his youth in this Spanish town (whose official name is Horta de San Juan) near the Mediterranean Sea was spent drawing and painting its landscapes and people. Years later, when he became a world-renowned artist, he returned to these lands where he established his artistic roots, to paint the same landscapes with his new avant-garde style. Rural life provides an endless source of inspiration and expansion because it is where the artist encounters nature in its purest form.

Jean-Baptiste Camille Corot (1796–1875). Mountainous Landscape. *Private collection. A painting is considered a rural landscape when its center of attention is a field, valley, or forest.*

Skyscapes

In most landscapes, the sky is a fundamental and present element. Sisley said in an 1892 interview, "It is not possible for the sky to become simply the background. . . . I pay special attention to that part of the landscape because I want you to understand how important it is to me. . . . I always begin my paintings with the sky." The source of light that defines the landscape comes from the sky. Light allows the viewer to capture not only the image but also its color and emotion, because the special character of every landscape depends on the quality of the light.

When the sky is not only an element of the landscape but also its main focus, we can consider the painting a skyscape. Skies are a specialty within landscape painting that deserve to be studied independently because of the magnificent works of art that have been devoted to the characteristics of the sky. Clouds, storms, fog, night, dawn, and sunsets of the most unimaginable color hang from museum walls worldwide because of their power in awakening emotions.

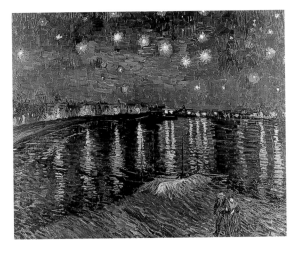

Vincent van Gogh, Starry Night, *1888. Private collection. Many of Van Gogh's skies are dense and textured. The use of the spatula in this painting contributes to the expressiveness of the scene.*

Marià Fortuny, Landscape, *c. 1874. Museo del Prado (Madrid). Two-thirds of the surface of this painting is devoted to the sky. Watercolor is a technique that lends itself to fresh, airy effects that provide a great feeling of visual expansion.*

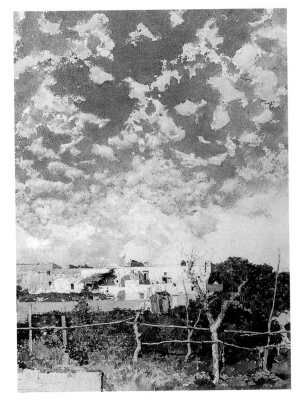

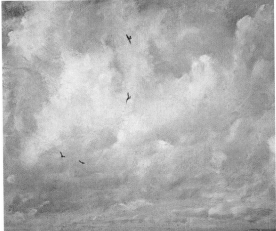

John Constable, Stratocumulus, *c. 1821. Yale Center for British Art (New Haven, Connecticut). The sky is an important element of any basic landscape for its spatial dimension and for the light that it emanates. It constitutes a landscape in itself and belongs to a genre with great tradition—the skyscape.*

River Landscapes

Water is a common element in landscapes, sometimes as the main focus, other times as an additional feature of the composition. The presence of water in a painting provides a special magic because of its freshness, cleanliness, and connotations of life. Also, water is the generator of new forms in motion within the landscape: the reflections and transparency of the new forms, always suggestive and mysterious, create all its magic. This type of landscape includes rivers and lakes, and is the rural equivalent of the seascapes. These landscapes can focus completely on the subject of moving water and the forms that it creates, or on the reflection of still water, which acts as a mirror duplicating the mountains and trees on its banks in harmonious creative play.

SEASCAPES

Another type of landscape that has captured the attention of artists is the seascape. The sea has always been a source of inspiration because of its immensity and life, and the effects of the waves. From a technical point of view, the reflection of the light also plays an important role. In terms of the conceptual focus, the sea affords the creation of living landscapes that are always in motion.

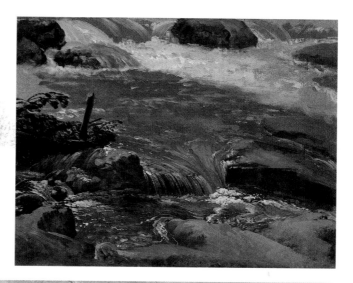

Simon Denis, River, c. 1789–1793. Private collection. The movement of the water in the river bends is a preferred element of this type of landscape, because of the dynamic and playful forms that it creates between the water and the rocks, which become almost abstract.

Paul Cézanne, Bridge over the Marne in Créteil, 1888. Pushkin Museum (Moscow). The still waters of this river act as pristine mirrors.

Landscapes of Everyday Life

Everyday-life themes include a creative current that has been present in every art period, beginning with Baroque. An everyday-life painting is one that shows scenes of the daily life of people from any region or culture. For this reason, it almost fulfills a documentary function. It was during the Baroque period that artists began to pay attention to people's daily routines. Painters discovered the aesthetic potential of those scenes where people occupied themselves with simple tasks, and they became magnificent works of art. Landscapes sometimes include scenes from everyday life, thus creating a perfect union between humans and nature, less so for the purpose of contemplation, as is the case of panoramic views, as for the action. People live in nature, and they get their sustenance by working it.

PAINTING AS A SOCIAL DOCUMENT
Everyday-life paintings are the visual documents of how people lived in the past. Impressionist painters acknowledged Millet as a master of this trend. Van Gogh painted portraits of numerous farmers and mine workers. Segantini also included the activity of sheepherders in his high-mountain landscapes. Other Impressionists, like Sisley, Pissarro, and Sorolla, also captured moments of spontaneous human activity in their landscapes. This natural documentary is inherent to everyday-life landscapes.

Giovanni Segantini, Nature Triptych. Nature, 1896–1898. Segantini Museum (St. Moritz, Switzerland). This posthumous work by Segantini summarizes his vital relationship with nature. Animals and people that live and work in those wild and pure areas appear in many of his landscapes.

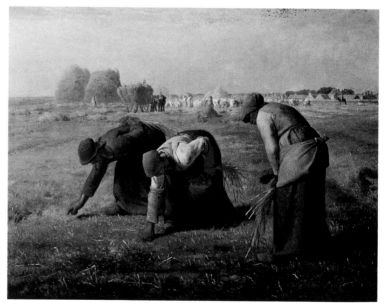

Jean-François Millet, Gleaners, 1857. Musée d'Orsay (Paris). Millet is one artist who best captured everyday-life scenes. His paintings exalt work in the fields, where humans and nature become one in a superb, realistic way.

Landscapes with People

Not every painting representing a person can be considered an everyday-life landscape. The intention of such painting may not be to show an action or social custom, but simply to reinforce the hospitable nature of the space or to show its dimensions by way of comparison. The human presence in a landscape is also a sign of vitality. The first landscapes in history always included people and had no reason to exist without them. They conveyed the message that nature was either to be enjoyed or to be controlled.

One of the most commonly used techniques was to place the figure at one side of the composition, reclined, standing, or with his back to the viewer to make the point that the important element was the landscape rather than the figure. The purpose of the figure was the enjoyment of the scenery, much like the spectator's enjoyment of the painting. Making sure that the viewer identifies with the figure in the painting, taking its place in it, is a classic technique of visual rhetoric.

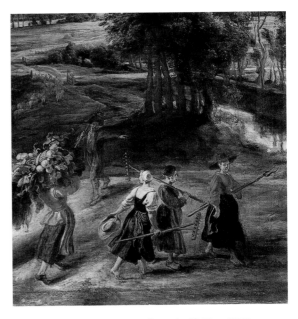

Peter Paul Rubens, Returning from the Field, *c. 1637. Galleria Palatina (Florence, Italy). The first landscapes in history always included people. The representation of space in landscape painting was conceived only as part of daily life or as a stage for war scenes or mythical narrative.*

Caspar David Friedrich, The White Cliffs of Rügen, *1818. Private collection. Romantic landscapes usually include one or several figures with their backs turned to the viewer in a pose of ecstatic contemplation before the beauty or power of the landscape.*

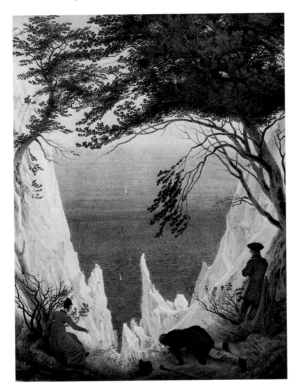

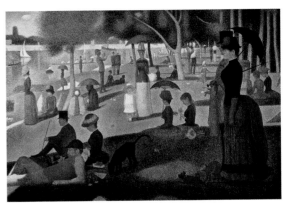

George-Pierre Seurat. Sunday Afternoon at the Grande Jatte, *1886. Art Institute (Chicago). In this landscape, the people walking and resting give meaning to the space, turning it into a relaxing scene.*

Landscapes with Animals

Although landscapes inspire a certain sense of stillness, in reality there is intense movement in them, because they always represent living things. The vegetation, as well as the trees and the atmospheric elements are dynamic, changing features; therefore, the inclusion of the animal kingdom makes complete sense in that context. Animals form an integral part of the living world, and that is exactly what a landscape is. Many landscapes represent the natural habitats of specific animals; birds are normally the subjects of this small group. However, most landscapes show domesticated animals, either as livestock—cows, sheep, goats, geese, and so on—or for companionship or labor—horses, oxen, dogs, and so on. For this reason, landscape paintings that represent animals also tend to include people, because both live in close contact.

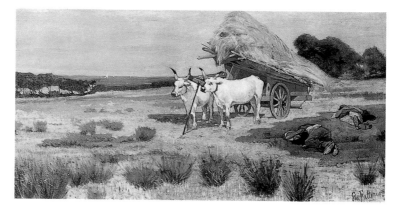

Giovanni Fattori, Resting in Maremma, *1873–1877. Private collection. Animals and people always appear together in rural landscapes that depict everyday life.*

THE INTEGRATION OF ANIMALS IN THE LANDSCAPE

To prevent the animals in the landscape from looking forced, it is important, from a technical standpoint, to treat them like the other elements in the painting. Therefore, making preliminary sketches from a life model is vital for acquiring a firm, steady hand at drawing them, and for achieving a natural integration.

Giovanni Segantini, Pasture in the Spring, *1896. Pinacoteca de Brera (Milan, Italy). The introduction of animals in landscapes produces more dynamic results. In terms of technique, Segantini paints the animals the same way he does the other elements, densely and with abundant texture.*

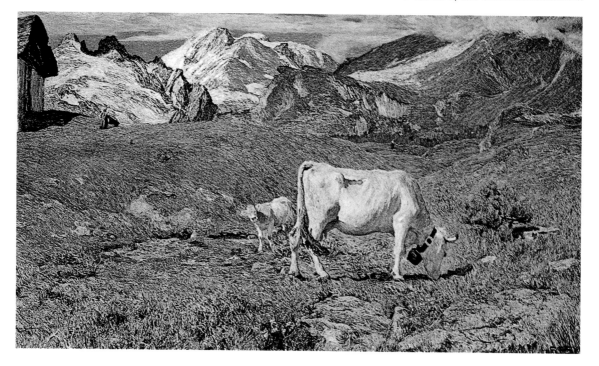

Landscapes with Architectural Elements

Seeing architectural elements in landscapes is not unusual. Animals build nests and have dens; therefore, the humans that inhabit nature also require their own shelter. The rustic architecture of rural villages has a special charm because it is based on its functional nature. Adobe, stone, wood, brick, or whitewashed walls and thatched, slate, tile, or stone roofs are some of the architectural variables that depend on the climate of the area. This type of architecture never has a decorative function in the landscape, and its natural character, firmly rooted through time, makes it become perfectly integrated. Besides, the presence of trees and vegetation around the houses and in the town's streets further reinforces that cultural symbiosis.

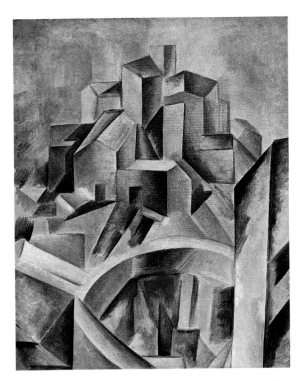

Pablo Picasso, Horta de Ebro, *1909. Private collection. In his Cubist period, Picasso returned to Spain, to the small village of Horta de San Juan, where he had been convalescent during his youth, to paint its houses and small streets. Here, the architecture is reduced to a dynamic play interaction of planes.*

Claude Monet, Rouen Cathedral in the Sun, *1894. Musée d'Orsay (Paris). When the development of the space in a landscape is completely focused on architectural features, the genre more resembles an urban landscape, even if the surrounding elements look more rural. Monet painted many versions of this subject under different light conditions.*

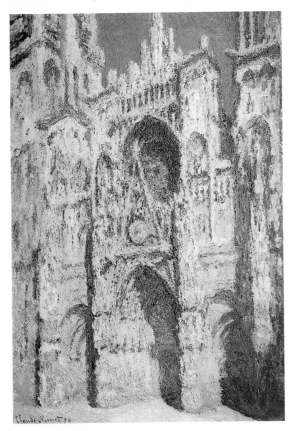

URBAN LANDSCAPE

An urban landscape depicts cities. This style had its origins in the Renaissance and was consolidated during the Impressionist period. A scene is considered urban when it takes place entirely in a city. Linear perspective is essential for planning this type of landscape, because of the geometric structure of the streets, buildings, and urban elements. In cities, light has a different quality, creating hard shadows, well-defined planes and contrasts, artificial and neutralized tones, or smoke and fog from pollution.

How to Paint Landscapes

The pages in this chapter present the basic theory for painting a landscape by showing how to work with all the elements included in the creative process: space, color, shape, texture, and line.

Just as the structure of the spoken language develops around some basic elements—words, silent gaps, and tone of voice—painting is also subject to a similar arrangement because it is also a type of language. The language of art is basically composed of shape, space, color, and technique. The first three elements comprise the image through perspective, chiaroscuro, and harmony, whereas the last one marks the expressive nature of the work through lines and texture. Much like spoken language where words, silent gaps, and intonation are arranged to form a sentence that makes sense, in painting, the composition encompasses all four elements combined to achieve a coherent result.

Landscape painting is basically spatial. To speak of landscapes is to speak of perspective. Therefore the first pages of this chapter will be devoted to the

◆

Landscape painting is basically spatial. To speak of landscapes is to speak of perspective.

◆

study of how this system for visually understanding space works.

The main rules that are applied to landscape painting with respect to color will be introduced in two large groups: color harmonies, which promote the saturation of color, and shading, which reinforces chiaroscuro through neutral applications.

For the study of form, we will review the different elements of a landscape separately: mountains, trees, houses, sky, water, figures, foliage, and so on. As far as technique is concerned, we will evaluate the different qualities of color and line, which will provide expressiveness to the painting. Finally, we will study composition by analyzing the most commonly used approaches in this genre and seeing their influence on the perception of the painting's space.

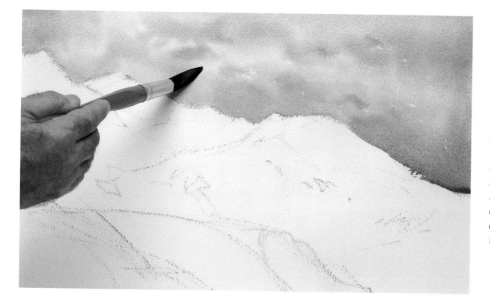

Each line or color applied to the canvas reflects a decision the artist had to make with respect to the color, shape, and orientation of the painting, as well as the expressive qualities of the subject. Painting is a language, and those decisions are the elements that create the speech.

To Capture the Light Is to Capture the Space

Light defines the image. If there is no light there is no visual perception; therefore, common sense dictates that a landscape is subject to the light that defines it. The general criteria stipulates that dark areas are perceived as distant and deep, whereas light ones represent closeness and superficiality. From this realization we deduce that a gradation requiring a transition from light to dark will always evoke depth. Drastic differences of light between objects also create distance. Therefore, if a tree in close proximity has a lot of light and one in the distance is dark, the perception of distance is greater than if both received the same amount of light. The way light is distributed in a landscape can help create abstract spatial sensations like emptiness, escape, depth, expansion, or atmosphere.

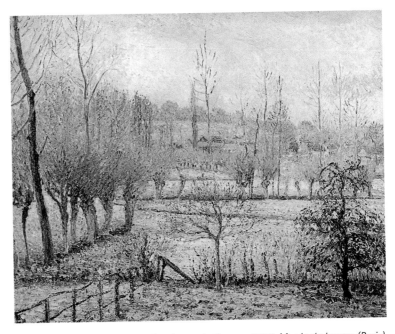

Camille Pissarro, Snowy Landscape in Eragny, *1894. Musée du Louvre (Paris). A simple light gradation creates the perception of distance. Pissarro has applied this principle in this landscape, which as a result of the snow has little definition and contrast.*

Gustave Courbet, The Stream of Puits Noir, *1865. Musée des Agustins (Toulouse, France). The characteristic forms of large landscape features, like rocks and tree trunks, are created with contrasts of light. The darkness of the shadow conceals the forms, turning them into a mass that suggests depth.*

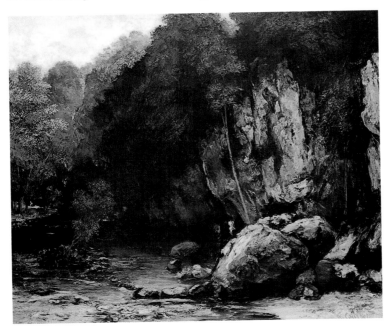

MANY TYPES OF LIGHT
The three factors that determine the type of light in a landscape are direction, quality, and intensity. The direction depends on the position of the sun according to the time of day. Quality defines the type of light: white, warm, cold, diffused, or direct. Intensity ranges from soft to very intense. Strong, direct light with the sun in high position causes a model to look harsh with few small but very dark shadows. On the other hand, the warm, delicate light of a sunset produces softer contours and colors, and very long but lighter shadows.

Linear Perspective in Landscapes

The visual perception of depth is conditioned by perspective. If the landscape has a linear structure (streets, roads, houses, gardens, and so on), we say that it has a linear perspective. If the structure is defined by masses (forests, valleys, mountains, rivers, meadows, and so on), we say that it has an aerial perspective. Both methods render the objects smaller and less defined as they recede in space toward the horizon. In the case of linear perspective, parallel lines are perceived as vanishing lines converging at a point located at the level of the horizon. A road, whose width is identical in its entire trajectory, will appear narrower the farther away it gets because of the vanishing effect of linear perspective.

THE HORIZON

The horizon is a line that marks the limits of our vision. It can be experienced on the ocean or on a flat terrain. If you extend your arm at eye level toward the horizon, you will notice that the horizon line is located exactly at that height. When the horizon is not visible because barriers are blocking it, simply extend the arm at eye level and imagine the line where the vanishing points converge. To speak of the horizon is to speak of the vanishing point. If the latter is high, the horizon will be high as well, and vice versa.

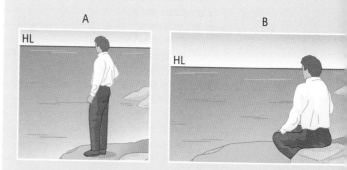

The horizon line (HL), which is only visible in clear surroundings, like in the ocean or on large plains, is always located at eye level. If the viewer is in front of the ocean on a small hill, the horizon will be high, and the spectator will be able to see a wide band of water (A).

If the viewer is on a lower level, the horizon line will be lower also, and the visible band of water will be narrower. If the spectator gets lower to the ground until he is laying flat, the line will become lower, to the point that it would almost disappear (B).

Alfred Sisley, Road of La Machine, Louveciennes, 1873. Musée d'Orsay (Paris). In this painting there is only one central vanishing point, which is where the two sides of the street converge. The horizon would be at eye level for a person walking on the street. Notice the reduction in size of the trees as they get farther away. This is a determining factor of perspective.

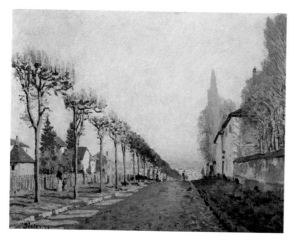

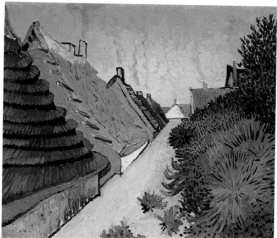

Vincent van Gogh, Houses in Saintes-Maries, 1888. Private collection. In this perspective, Van Gogh has chosen the view from a high point on the road, and this has elevated the view of the horizon, making more of the ground visible.

Vanishing Points and Depth

The lines that converge in the horizon are called *vanishing lines* and create a perception of depth and distance. They converge in a place called the *vanishing point*, which is always located at the horizon line. One single painting can have several vanishing points, depending on the number of elements and their positions. Parallel objects will have the same vanishing point, but the rest will not. In any case, all vanishing points always converge at the level of the horizon line.

If the observer is facing the feature directly—for example, a road—there will be only one vanishing point for that road, and the perspective will be frontal. On the other hand, if the viewer is positioned in another way that is not facing the object—for example, a house from a corner—there will be two vanishing points, and the perspective will be oblique.

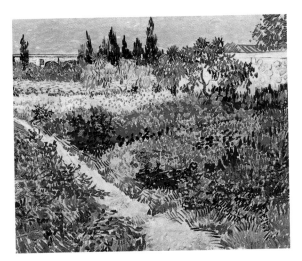

Vincent van Gogh, Garden with Flowers, *1888. Private collection. Linear perspective is applied not only to architectural elements, roads, and railroads but also to many gardens and fields, which have a linear structure that must be taken into consideration before painting begins. In this case, Van Gogh has established two vanishing points (VP). It is an oblique perspective.*

SP - station point
PP - picture plane
GP - ground plane
HL - horizon line
VP - vanishing point

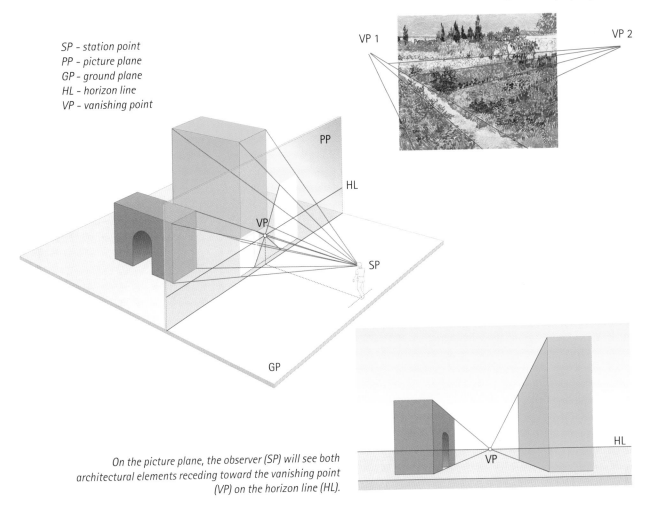

On the picture plane, the observer (SP) will see both architectural elements receding toward the vanishing point (VP) on the horizon line (HL).

The Basics of Aerial Perspective

Most landscapes do not have linear perspective. A field of poppies, a valley with foliage, the mountains in the distance, and a forest in fall are all subject to different laws of perspective. In his *Treatise of Painting*, Leonardo da Vinci wrote the guidelines for this type of perspective, which he called atmospheric, based on the effect of the atmospheric light on forms and spaces located far away. By studying how this type of landscape is perceived, one can figure out how it has to be represented. There are three general guidelines to follow. First, we must consider that as the objects recede, not only do they become progressively smaller but their definition is also decreased. Second, the effect of contrast is also reduced, because as distance increases the objects become grayer. Finally, it is observed that in the distance, colors become cooler, until they ultimately turn blue. This phenomenon is noticeable when looking at mountains in the distance.

Henri Rousseau, Landscape with Sunset, *1910. Kunstmuseum (Basil, Switzerland). In this work painted in the naive style, the feeling of depth is created by simply changing the size of the elements, because all have the same level of definition and contrast.*

Distant blue planes (1).
Warm close planes (2).
Size, definition, and contrast increases with proximity (3).
Size, definition, and contrast decreases with distance (4).
Details only in close proximity (5).

SCALE

The most primitive method for representing distance graphically is to change the scale. Things look smaller the farther away they are, and this obvious principle is the basis of the method applied to naive, or primitive, style paintings. Without changing either the contrast or the definition, it is possible to represent distant elements in the same landscape by simply reducing the scale of the objects that are far away.

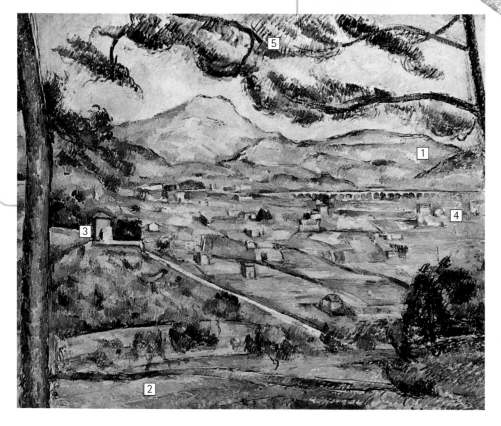

Paul Cézanne, Mountain of Sainte-Victoire with Big Pine Tree, 1886–1887. Phillips Collection (Washington, D.C.).

Focus and Distance

A method for creating visual distance between two elements that are on the same plane is to paint one in focus and the other out of focus. Although both may be close, representing one out of focus makes it appear more distant than it really is. This strategy, which is common in photography, can be applied to painting the same way, using techniques such as partial erasing, diffusion by blending the paint with a brush, lightening the area, or making a sketchy drawing of the object that is to be shown in the distance. These methods are normally applied in landscapes with reduced visual fields, in medium and short distances, so the perception of depth appears exaggerated.

William Turner, Saint Michael's Castle, Bonneville, Savoy, *1803. Yale Center of British Art (New Haven, Connecticut). This is a clear example of how colors look cooler in the distance. It also shows how the projections of the shadows develop in the space.*

Vincent van Gogh, Tree Trunks in the Grass, *1890. The Kröller-Müller Museum (Otterlo, Netherlands). Notice the difference between the treatment of the nearby trunks and those in the distance, which are represented with simple green brush strokes. The bark of the first trunk shows more definition and contrast, but as the image recedes the effect decreases considerably.*

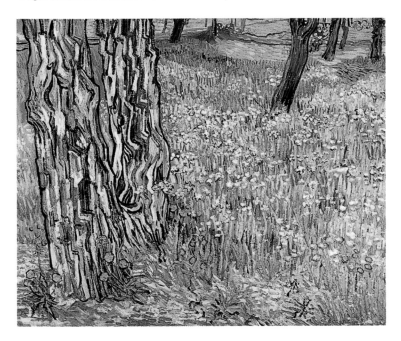

PROJECTED SHADOWS
Every illuminated object projects its shadow into space, following the direction of the light and in the opposite direction from its source. Shadows duplicate the form of the object by projecting a silhouette that is not perfectly defined. Shadows also appear deformed as a result of the features on the terrain and are elongated or flattened, depending on the position of the sun. The color of the shadow is the color of the ground onto which it is projected, rather than the color of the object, although it is darker in value. Impressionist painters used to add blue to the shadows to make them visually cooler and to create a feeling of distance.

Basic Rules of Color

To be able to paint a landscape correctly, it is important to know how the color wheel works and to remember where the colors are placed on that wheel. First, we can identify three primary colors: lemon yellow, cyan blue, and magenta red (for practical purposes, magenta red can be substituted with carmine red; cyan blue, with Prussian blue). By mixing two primary colors, we get a secondary color: green, blue-violet, or red-orange. By mixing a primary and a secondary color, we get a tertiary color: bluish green, yellow-orange, and so on.

Two relationships can be identified among the colors of the wheel: complementary colors, which are pairs of hues located opposite each other on the wheel, such as yellow and violet, and adjacent colors, which are located near each other, such as yellow and orange. A tint is obtained by mixing a color with its adjacent color because the tone is the only thing that changes. But if a color is mixed with its complementary color, the result is gray, which turns darker until it gets black, based on its saturation and value.

LIGHTENING AND DARKENING COLORS
A color is normally mixed with white to make it lighter. It can also be mixed with a small amount of the brightest adjacent color, although this is not always recommended because the tone can change. To darken a color, simply mix it with its complementary color, trying not to lose the initial tone from excess of the other color. Sometimes, also a small amount of the darker adjacent color, or black, can also be added to the mixture, although this could muddy the color rather than darken it. The use of excessive white or black in the mixtures produces monotonous colors and lack of chromatic richness; this is why they should be handled with caution.

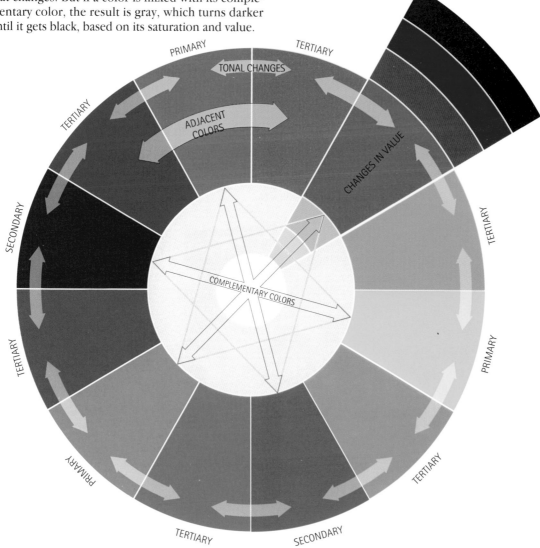

Colorist Landscapes

Color harmony is the result of combining colors in a pleasing way, according to a determined expressive criteria. Colorist paintings are those that use intense colors in their purest form or maximum saturation. This kind of painting does not make use of gray and dull or dark colors; therefore, mixtures between complementary colors or with black are rare. A colorist chiaroscuro is mostly based on color temperatures (warm or cool) and on contrasts between complementary tones; therefore, blue is used to paint the shadow of an orange mountain; violet, a mountain with a yellow undertone.

Van Gogh used to say: "Instead of trying to replicate exactly what I have before my eyes, I use color more arbitrarily to force personal expression." According to Van Gogh's free spirit, color should be displayed in all its glory, sometimes in an exaggerated manner.

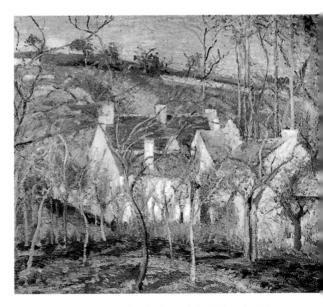

Camille Pissarro, Red Roofs, Part of the Village in Winter, 1877. Musée du Louvre (Paris). This is a clear example of an Impressionist color palette. Pissarro spent many hours studying light and color in landscapes.

Henri Matisse, View of Collioure, 1906. The Hermitage (Saint Petersburg, Russia). The Fauvist landscapes were created with pure colors—without earth tones, complementary colors, or black—to make them more dynamic.

IMPRESSIONIST COLORS
Impressionist artists painted landscapes using colors based on complementary combinations: blues and oranges, yellows and violets, greens and reds. Of those, warm colors (orange, yellow, and red) emanate light, and cool colors (blue, green, and violet) inspire shadow. The Impressionist style does incorporate earth tones and complementary colors in their palette to produce intermediate tones, even though their technique favors color and not value, but at this stage of the painting, they were in pursuit of a natural appearance for their colorist impression.

Tonal Landscapes

A tonal landscape incorporates colors darkened through neutralization. This is done by reducing their natural brightness through combinations with their complementary colors or with black and earth tones. This is the traditional method of producing chiaroscuro—in fact, these paintings are visually more realistic than colorist ones, although they may have a surreal feeling. The color ranges obtained through neutralization are also called *intermediate*.

Let's see some examples. If orange is mixed with a small amount of blue, it acquires an earthy tone. If a little bit of red is added to green, the resulting color will be maroon—purple if the green had more blue in it, and earthy if it had more yellow. If white is added to all these colors, we will get a cream tone or a lighter shade of green, red, and so on. Intermediate colors are beautiful and extraordinarily suggestive.

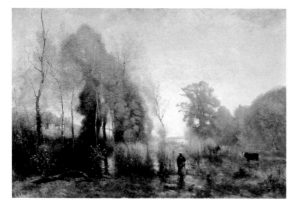

Jean-Baptiste Camille Corot (1796–1875), Ville-d'Avray. Musée du Louvre (Paris). *The treatment of light in this landscape has its roots in the Baroque chiaroscuro. Although the color range is intermediate, earth tones predominate. Notice the array of nuances that Corot was able to incorporate.*

Camille Pissarro, Harvest in Montfoucault, *1876. Musée du Louvre (Paris). A tonal painting like this one does not necessarily have to use a palette of intermediate colors; it can incorporate the natural colors of the landscape, without reducing or enhancing them. This is known as naturalism.*

Henri Matisse, Path in the Bois de Boulogne, *1902. Pushkin Museum (Moscow). A colorist painter like Matisse also produced landscapes that were at the far end of the Fauvist color spectrum. For this one, he chose a radical intermediate palette.*

Creating Depth with Color

In his *Color Theory* (1810), Goethe developed a relationship between colors and the effect that they produce. He established through experimentation that warm colors (yellows, oranges, reds, and red-violets) create a dynamic feeling and an effect of proximity, whereas cool colors (blue-greens, blues, and blue-violets) produce the effect of calm and distance. Although black and white are neutral, the former is associated with cool colors and the latter with warm.

Keeping in mind this scientific approach, Romantic, Neoclassic, and Impressionist artists applied these principles by creating color gradations to produce a feeling of depth through color. The method is simple: The artist only needs to go from warm to cool colors, progressing through intermediate tones, greenish or violet, depending on the overall warmer or cooler effect.

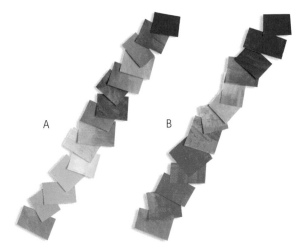

The transition from orange to blue, through yellows and greens, is the most natural method that traditional artists use (A).
Progressing to blue from orange, through reds and violets, is an alternative system that forces the composition, but that is warm and powerful (B).

TWO EXAMPLES BY CÉZANNE

Let's consider two landscape paintings by the same artist, with very different purposes. One is an intimate painting, whereas the other is more panoramic. For the latter one, the mountains in Provence, the artist chose a color gradation that highlights green in its intermediate range, more natural and fresh than violet. For the intimate landscape with trees, he used purples and violets. In both cases, the color determines depth.

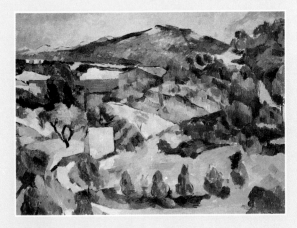

Paul Cézanne, Mountains in Provence, 1886–1890. National Museum and Gallery of Wales (Cardiff, Wales).

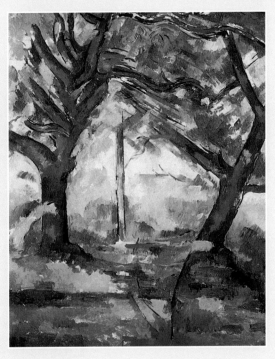

Paul Cézanne, Trees. National Galleries of Scotland (Edinburgh, Scotland).

Creating a Landscape with Blocks of Color

The two most common forms of creating a painting, depending on the size of the mark and the tool used to create it, are lines and blocks of color. A line describes an impression that extends in one direction. The blocks of color on the other hand suggest two—in other words, they occupy a larger surface. A landscape can be created with blocks of color by reproducing the formal characteristic elements of atmosphere and relief.

To achieve this, the blocks of color are applied with several guidelines in mind. The first one involves the tonal effect, with which chiaroscuro is created. During this phase, the direction and the shape of the stroke is extremely important, and should be applied depicting the shape of the object and taking into account its own and projected areas of light and shadow. The second approach is the colorist. The areas of color are established in the composition with loose brush strokes. Finally, texture is introduced by applying thicker or thinner paint, depending on the landscape's atmospheric feeling.

A VARIETY OF MATERIALS
It is a good idea to experiment with a variety of materials to produce different effects. Brushes of various shapes and sizes, as well as spatulas, rags, sponges, or even the fingers, can determine the richness of the result.

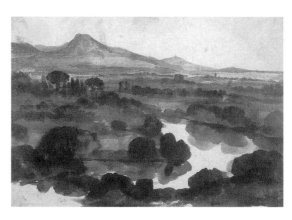

Claude Lorrain, The Tiber seen from Mount Mario, c. 1640. *Musée du Louvre (Paris). A wash always creates lighter volumes and masses than other techniques.*

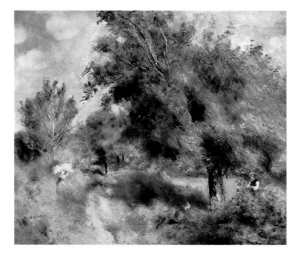

Pierre-August Renoir, An English Pear Orchard, 1885. *Private collection. The effect of the brush stroke that Renoir uses in this landscape is airy and soft. The brush strokes mix with one another to produce an atmospheric an unrealistic effect.*

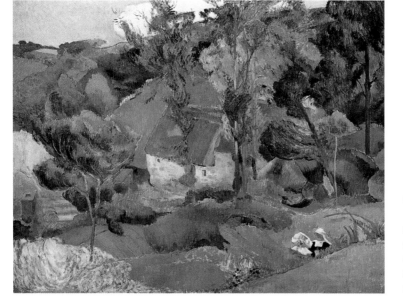

Paul Gauguin, The Aven in Pont-Aven, 1888. *Private collection. The brush stroke can take on different shapes depending on the technique and the intention of the artist. In this rural scene, Gauguin built the landscape with thick, flat brush strokes.*

Constructing a Landscape with Lines

Although a painting usually includes a combination of lines and blocks of color, it is interesting to work with only one of them, the line. This method is very expressive because of its direct and descriptive effect. Van Gogh, for example, produced most of his work with linear brush strokes, which described the surfaces and forms of the landscapes with texture and relief.

The same way each person has a particular handwriting style, which has to do with the individual's personality, every artist knows how to create different line qualities according to their expressiveness. In any case, lines can be incorporated into a landscape to describe different textures, to model objects, to define contours, or to structure the images. Although a line by itself does not exist in nature—except in branches or flower stalks—it is an expressive artistic technique.

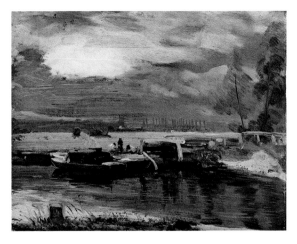

John Constable, Boats on the Stour, *1810–1812. Victoria and Albert Museum (London). This artist has a remarkable ability for defining elements such as trees, water, and boats, using various lines created with quick, firm brush strokes.*

Vincent van Gogh, Summer Evening, Wheat Field at Sunset, *1888. Kunstmuseum (Winterthur, Switzerland). In this oil painting, Van Gogh defines the entire wheat field with linear strokes, varying their size and direction to create depth.*

LINE QUALITY
Four factors influence the quality of the line. A different effect will be achieved depending on the combination selected by the artist:

- the tool (brush, pencil, dip pen, reed pen, the finger, and so on);
- the speed (very fast, normal, slow, and so on);
- the intensity (depending on the pressure or the amount of paint);
- the shape (straight, wavy, broken, in modules, and so on).

Vincent van Gogh, Summer Evening, *1888. Kunstmuseum (Winterthur, Switzerland). In the ink drawing that Van Gogh sent his brother Theo, it can be observed how the artist translated the color and lines of his oil painting into the ink lines and hatching.*

Architectural Shapes in Landscapes

The biggest problem with including architectural features in landscapes is representing the objects in too much detail. Architecture should be incorporated into the landscape as part of it; therefore, it should be treated like the rest of the elements (clouds, foliage, mountains, trees, and so on). If the landscape is executed with delicate, layered brush strokes, the architecture should be treated the same way. On the other hand, if the brush strokes are loose and free, the buildings should be represented the same way.

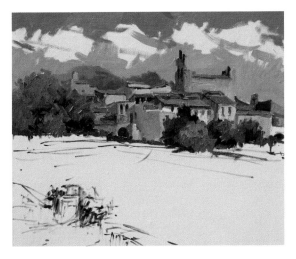

Towns are reduced to planes of color, without ever defining them in detail, applying the same chiaroscuro guidelines as for a single building, and making sure that all structures are lit from the same direction.

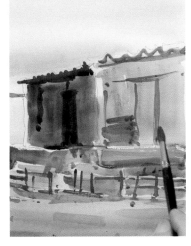

The artist can resort to combinations of lines and strokes of color to illustrate architecture that is nearer the viewer.

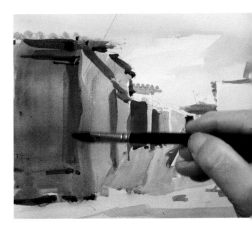

It would be a mistake to treat the line as a contour and the color as filler. Both techniques should overlap and complement each other, depending on the structural elements (walls, doors, fences, roofs, and so on).

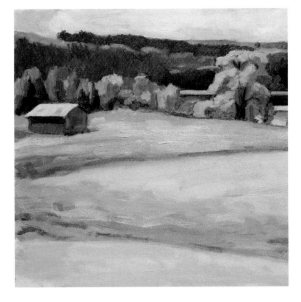

When painting houses in the distance, the overall structure of the landscape should be evaluated and its complexity reduced to simple geometric shapes executed in chiaroscuro.

LOOKING AT THE STRUCTURE

Architectural structure should always be taken into consideration when painting buildings, because it helps define the shape of them. In fact, lines, no matter their function, do not exist in the eye of the viewer; they are part of the creative process of the painting. The surfaces that have been modeled with light and shadow effects look different from those that have been defined with lines; therefore, it is never a good idea to draw a contour and then fill it with color, unless the artist wants to achieve a naive effect.

Painting Mountains, Valleys, and Rocks

In principle, painting a landscape should be no different than painting clothing or any other object, because it is a matter of representing volumes and textures. To represent volumes, the normal chiaroscuro technique can be used, whether using a tonal color harmony approach or colorist method, studying the intensity of the light, and the type of forms that it creates. Representing textures is a more complex matter because of the great number of effects that can be achieved. Therefore, it is a good idea to experiment first with the medium, combining resources and techniques like impasto, brush strokes, washes, blending, and scratching; changing the speed, intensity, and form, if needed; and using various tools (brush, spatula, fingers, rags, sponges, and so on). Variety is one of the paths to achieving success when faced with this type of challenge.

This oil sketch by Josep Verdaguer is a magnificent example of the modeling of a valley using brush strokes of color applied in different directions and combining rich varieties of green.

The rocky surface and the stones on the ground are painted using various colors and shapes, as is shown in this work by Ferdinand Hodler. Otherwise, the theme would be monotonous and lacking expression.

A daring combination of brush strokes and lines of different sizes and colors can greatly enrich the representation of the terrain, as shown in this watercolor by Vicenç Ballestar.

Painting Trees

A tree presents a rich variety of spaces and volumes, this is why trees are sometimes the only subject of a landscape painting. The way to approach painting a tree always begins with its structure: trunk and foliage. The first steps should be sketchy and gradually progress from there until the complex volume is completed. The final brush strokes should be devoted to the details, which will be greater for trees that are closer to the viewer and fewer for those located in the distance. Practicing sketching a tree with one, two, or three brush strokes is a good exercise that can later be valuable for painting landscapes. The type of tree will dictate the brush stroke that is required. For a birch tree, a short brush stroke using a round or filbert brush will be the most appropriate, whereas for a pine tree, short, curvy lines painted upward with a thin, flat brush would be best. It is a good idea to experiment with these tools and techniques until the most appropriate combination is found for the character of each tree species.

The volume of a tree is created by superimposing blocks of color. Different densities will be created if the strokes of color are built up with transparent brush strokes, this way the trees will not appear lifeless or as if they were cutouts.

A tree that occupies the foreground of a painting should be depicted using shape and volume, increasing contrast and defining textures.

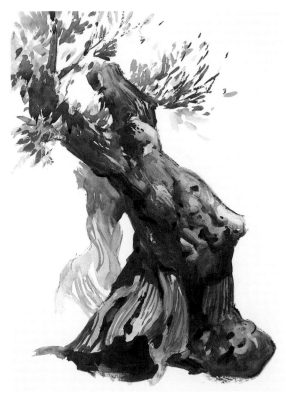

1 This tree, painted with acrylics, was created by applying the darker tones first.

2 Then, the intermediate tones were applied, adding some openings among the foliage and the branches.

3 To complete the tree, the lighter tones were applied, creating new nuances to enrich the different tones of green.

Integrating Figures in a Landscape

Much like trees and houses, figures also deserve special attention when they are introduced in the overall scheme of a landscape. Normally, the challenges presented are similar to those involving other elements, as indicated before, and the artist should decide whether to paint the figures loosely or in detail. Therefore, the techniques already introduced are valid for this exercise as well because in terms of style, figures should be treated like any other element of the painting. Knowing how to sketch is also a valuable skill for representing figures in the distance and at midrange. Sketching is not as important for painting closer figures, as knowing how to develop the details. To gain confidence with these skills, it is important to practice beforehand to understand not only the direction of the brush stroke but also how the correct gesture and volume of a figure should be created.

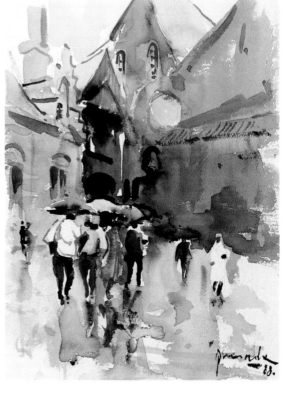

In this watercolor by Julio Quesada, notice how the figures have been perfectly integrated into the landscape, by applying the same type of brush strokes for the entire scene, both for the people and the houses.

Painting the people in this case is simple, although not easy. It consists of applying simple brush strokes in such way that a few applications of color define the posture and volume of the figures.

Painting the Sky

The way to paint the sky is by closely observing the light, color, and volume of the clouds. Technically, one begins by painting the background, applying full or graded color, depending on the time of day. Next, the clouds are introduced, modeling their volumes, following the preliminary drawing and using conventional chiaroscuro techniques, but applying a particular texture. Blending and controlled washes produce the soft and airy look of the clouds. As for color, possibilities range from the light cerulean blue to the darker, grayish blue with burnt sienna, for stormy skies. The truth is no two skies look alike and there is no magic formula to paint them, because colors can vary greatly depending on the time of day and location. Close observation is the only path to color success.

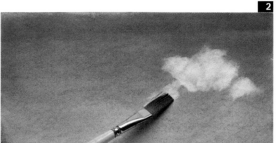

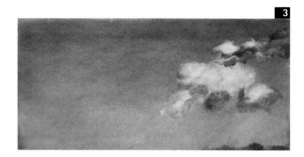

1 With a wet technique, like watercolors, the first approach is the application of an overall, even tone.

2 Using a wet brush, the still wet paint is removed to create white areas on the surface.

3 The final volume is created by incorporating other darker tones, without letting them dry completely to produce some areas of blended color. Sharper details and less airiness can be achieved by working with drier colors.

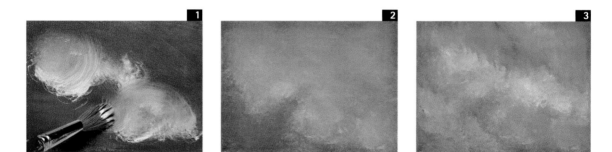

1 Clouds in oil are created by using sufficient paint to allow spreading and blending. The background color is applied first, and then white is added.

2 The airy-looking mist is created over the freshly painted base, leaving some areas lighter than others.

3 Dark contrasts are created by introducing a darker tone, which can be mixed by adding a little bit of its complementary to the base color.

4 The final touches reinforce the light and define the shapes.

Textures of the Terrain

Different painting techniques should be used depending on the type of terrain. Ground that is covered with grass and bushes will have such a leafy appearance that it will require loose and varied brush strokes with rich contrasts of greens. However, ground that is dry and rugged would be better developed with large areas of contrasting light, like scales of different sizes applied a spatula or a wide brush. The direction and size of the applications is vital because it will determine the ground's feeling of depth. The lower areas of the painting correspond to the foreground of the terrain and larger, more contrasted brush strokes should be applied. The upper areas, corresponding to the features in the distance, should have smaller brush strokes with less contrast. As for the orientation of the brush strokes, they should conform to the modeling of the terrain. Horizontal applications convey a feeling of flatness, whereas vertical and slanted ones define plants and grass. Repeating the same rhythm conveys a feeling of order in the vegetation, like a planted field, which does not exist in wild terrain.

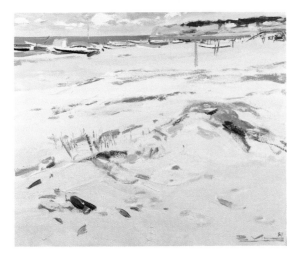

To represent irregularities on ground that is sandy or muddy, like the one in the illustration by Pere Lluís Via, the brush strokes should be of different sizes and directions, and the larger, flat areas should be defined with slight variations of color.

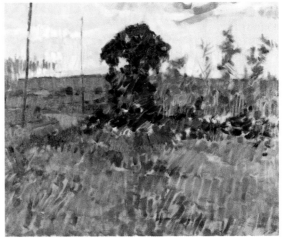

The textures of fields, like the one in this painting by Verdaguer, are created with variations of green, establishing a rhythm for the brush that is more or less regular, but not monotonous.

PLEIN AIR PAINTING

Painting landscapes outdoors was popular with the impressionists, because it was the most direct way to capture what the artists painting in this style pursued, "the impression." Working outdoors has the disadvantage of being exposed to inclement weather, but it has the advantage of feeling the landscape more intensely.

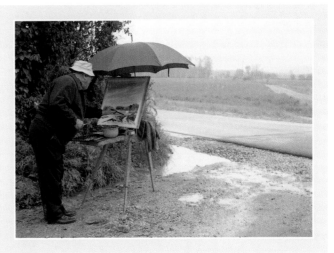

Painting en plein air on a rainy day.

Painting Water

To correctly paint water in a landscape, it is important to treat it as if it were part of the texture of the painting. Water itself is transparent and does not have color of its own, but it takes on the color of the environment that surrounds it. It is important not to make the mistake of painting a river systematically blue or green, because it can be brown, yellow or gray if the surroundings are that color. Still water creates a perfect reflection of the objects around it, as if it were a mirror, in such way that the image in the water will be clear but inverted and less defined. Everything changes if the water is moving. Depending on the speed of the water, the images will still be reflected, but their silhouettes will be cut off or reduced to streaks of color adapted to the shapes found in the water's path, with multiple highlights and dark areas.

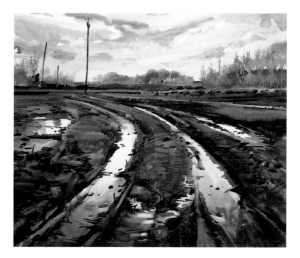

In a puddle, the water is stagnant and acts like a mirror. In this watercolor by Vicenç Ballestar, the water directly reflects the light from the sky. The contrast of the light and the texture between the mud and the water are what create the perception of still water.

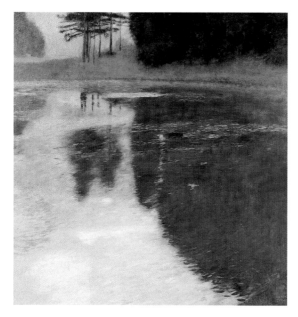

Gustav Klimt, The Pond in Kammer Park, 1899. Private collection. The shapes reflected in the water are distorted in response to its movement. In this work by Klimt, a soft breeze disturbs the outlines and generates numerous reflections of light.

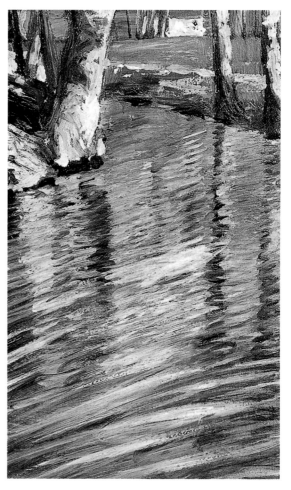

Egon Schiele, Pond with Reflections of Trees, 1907. Private collection. The direction of the brush strokes determine the movement of the water in this pond.

Foliage

When trees and plants are not viewed as separate entities but as a group, the vegetation appears more like texture than as shapes, because it is perceived as a forest, brush, field, or thicket. The treatment of this grouping is similar to that of fields and mountains. Combining and repeating the brush strokes using lines or blocks of color to create an overall texture reproduces the color and type of vegetation of the place. The form and direction of the brush stroke is what will define the vegetation in question. An attempt should be made not to go into too much detail when painting plants, unless they are located in the foreground.

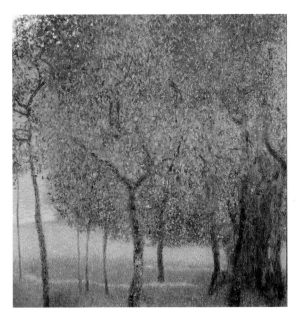

Gustav Klimt, Fruit Trees, *1901. Private collection. Klimt developed the foliage of the trees with a style that resembles pointillism, using minute brush strokes of different light and color.*

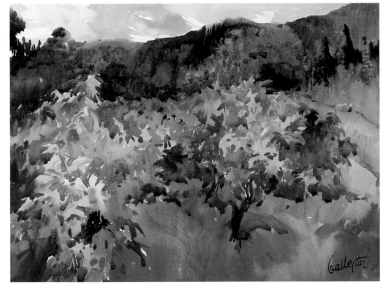

The loose and dynamic brush strokes of Vicenç Ballestar define the foliage of these grapevines. The chiaroscuro and the color variations provide richness and freshness.

John Singer Sargent, Palm Trees, Florida, *1917. The Metropolitan Museum of Art (New York). Each plant has different foliage. Sometimes it is important to pay attention to the kind of plant, to determine the type of brush stroke needed to paint it. In this watercolor, Sargent has created rich linear texture to define the foliage of this plant, which has a lot of personality.*

GREEN

When painting foliage, it is important to consider the wide range of greens that can be created from the different blues and yellows, combining them also with white to create lighter and more luminous greens. Some earth colors, like raw amber, already have a green undertone, and the yellows mixed with black also produce green. It is a good idea to include carmine, vermilion, and burnt sienna when mixing greens, although overusing them in the mixture is not recommended because they will make the greens turn brown or maroon.

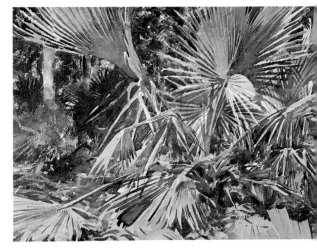

Landscape and Composition

Composition is the arrangement of the various areas of the painting in accord with an overall sense, an expressive interaction. Connecting the parts into a whole is accomplished by evaluating the visual space logically and by composing a structure that balances the masses and the spaces of the painting. Normally, every landscape has a focus of interest, even when it is a panoramic view, and it is to that point that the viewer's attention is usually directed when observing the painting. But there are some exceptions—for example, when the landscape's point of interest is the texture and where no element in particular stands out. In these cases, defining a focal point is the first compositional decision that the artist must make, and if the artist looks for the element that first captures his attention in the landscape it is not a difficult decision. Other important decisions include the painting's format (square, rectangular, narrow, vertical, horizontal, and so on), the scale (short range, medium, or long), and the orientation (centered, sided, slanted, and so on).

Vincent van Gogh, Flowering Branches of an Almond Tree, *1890 Rijksmuseum (Amsterdam). Grid composition. Van Gogh has filled up the entire space by intertwining all the elements to create a formal canvas.*

Grid composition.

Gustav Klimt, The Great Poplar Tree, *1903. Private collection. Composition based on right angles. Combining vertical and horizontal planes creates a feeling of balance and order without comparison.*

Pyramidal composition.

Orthogonal composition.

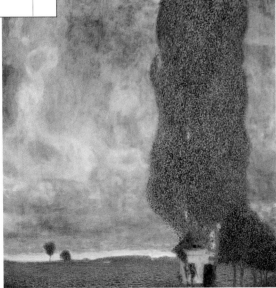

Jordi Muntada Roca, Imatge del Desert XII, *2002. Private collection. Pyramid-type composition style. Although the main focus is on the entire dune, the soft angle that the artist has placed at the crest adds a dynamic feeling and a sense of depth to this minimalist painting.*

Framing

In the landscape genre, composition is equivalent to framing. The artist has no other choice but to place the point of view closer or farther away, to choose a vanishing point, and to search the horizon for a focal point that best responds to the desired composition. This search for a composition is most closely related to what a camera with a zoom would do when taking pictures of that scene: select an area of the landscape, focus the image closer or farther away, and place all the elements within the frame, deciding if the orientation of the picture will be horizontal or vertical. This evaluation should respond to a personal style, and the artist should consider different options before repeating the same type of composition.

Claude Monet, Poppy Fields near Giverny, *1885. Museum of Fine Arts (Boston). Crossed composition. Although this arrangement is traditionally applied to frontal perspectives, this painting by Monet is a good example of the method that can be used for more rural scenes, like valleys and prairies.*

Crossed composition.

FRAMING DEVICE

Framing consists of placing something within a picture. The artist can use a device that resembles a frame or window that can be moved across the scene to find the most suitable arrangement. With two strips of black cardboard cut at right angles, the artist can construct a simple but effective frame. It is better to use adhesive tape or a paper clip, instead of glue, to adhere the pieces, this way it can be reused for other applications and different formats.

Horizontal composition.

Giovanni Segantini, Landscape, *1896–1899. Private collection. Horizontal composition. The horizon sets the tone for the painting. The effect is always static and calm because the open space and the visual depth promote that feeling.*

Laying Out the Picture

When creating a composition, it is important to try to see the scene abstractly so that everything is reduced to a combination of mass and space. Every element has a place in this analysis, and normally one speaks in terms of weight. Dark shapes have more weight than light ones and larger ones more weight than smaller ones. Therefore, a very large shape (a forest) located to one side of the painting will require a counterbalance at the other side (a mass of land of a lighter color than the forest but larger in size, or a smaller but heavier element, like a darker house). This would be the general approach, but logically the artist can play with the arrangement at will and to look at creating tension and lack of balance to exaggerate some aspect of the work. For example, in the previous scenario, the forest could be moved to the upper part of the painting to emphasize the ground or to the lower part to highlight the sky. In any case, this is a matter of intuition and of a personal sense of expression.

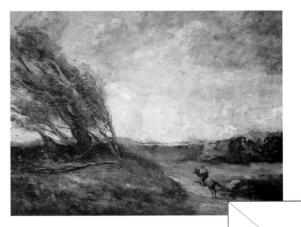

Jean-Baptiste Camille Corot, Wind Storm, *1865–1870. Galleria d'Arte Moderna (Milan, Italy). Diagonal composition. This interesting scenic landscape is dynamic thanks to the diagonal arrangement used by the artist and the simple, but striking techniques involved.*

Diagonal composition.

Gustave Courbet, Loue Valley, *1849. Musée des Beaux-Arts (Strasbourg, France). Composition in zigzag leading up to the horizon. This compositional structure is the most appropriate for leading the eye because it lays out a path that leads to the horizon, crossing each plane, from the closest to farthest away.*

THE LAW OF ASYMMETRIC BALANCE

Mass and space are organized on the surface of the painting according to the following guideline: The greater the mass the shorter the distance to the center of the painting, and vice versa. Each shape should be placed on the picture plane as if they were on the arms of a scale and the weight distributed to maintain a visual balance.

Zigzag composition.

Vincent van Gogh, Girl in a Forest, *1882. The Kröller-Müller Museum (Otterlo, Netherlands). Classic angled composition. The vanishing point is located in a corner of the painting to highlight the visual path along the diagonal line.*

Angled composition.

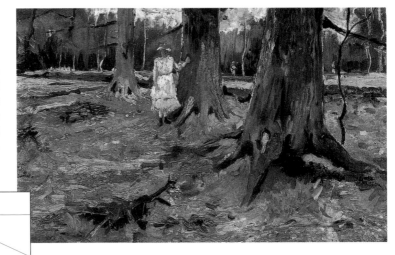

The Format

Whereas a camera can change only the orientation of the picture from horizontal to vertical, with painting, both the dimension and the format of the composition of a painting can be changed at will. Many countries have already established standard formats for each genre (figure painting, landscapes, seascapes, square, and so on) because there is a tradition based on experience, which dictates the appropriate format for each one. Experimenting with new formats is truly gratifying because it provides an opportunity for creating new, more personal compositions. Besides, many scenes have a complex focal point and require special formats to reinforce the theme. The most popular format is rectangular, but there are many types of rectangles. The narrower the rectangle the more difficult the composition, because this format will almost completely determine the layout and distribution of the work.

Oriental landscape from the fifteenth century attributed to Tai Tsin. Many oriental landscapes are vertical. This type of format reinforces a deep visual space creating a grandiose feeling.

Jean-Auguste-Dominique Ingres, View of the Aqueduct at Villa Borghese, c. 1806. Musée Ingres (Montauban, France). During the Neoclassic period, many artists resorted to a circular format for a more elegant look, though the format does create a sense of distance between the observer and the painting, giving the feeling that the viewer is looking through binoculars.

Albrecht Dürer, View of Arno, c. 1495. Musée du Louvre (Paris). Artists have been using square formats for a long time, as shown by this Renaissance painting. This format provides a balance that works well for centered landscapes.

Giovanni Fattori, Red Tower, 1875. Civic Museum Giovanni Fattori (Livorno, Italy). Horizontal formats are the most common for landscape paintings, especially for panoramic views, because of the visual relationship that it establishes with the horizon.

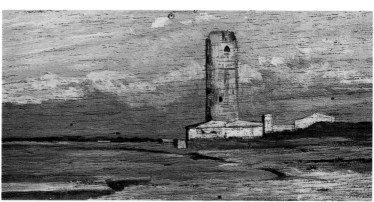

Landscapes and Dry Techniques: Pencil, Charcoal, and Pastels

Dry techniques are those that do not require a diluent (water or mineral spirits). They are normally made of raw material with a binder, except in some cases where there is not even a binder—for example graphite and charcoal. They are available in sticks of various thicknesses, sometimes also in pencil form. Dry techniques are applied to surfaces that do not require priming, like paper or cardboard. It is a good idea to work on a hard surface because pressure is needed to apply them. Most of these techniques are reversible and can be corrected by erasing. Erasers and rags are also useful tools to continue working on the drawing and creating white lines.

Pastels are made by combining pigment with tragacanth gum. Light colors contain white, which is why they are called pastels, and dark ones have black. They are available individually or boxed in a wide variety of colors. Pastels are applied and mixed directly on the paper, and they are manipulated to create lines and masses of color. Pastels are easy to blend and are ideal for landscapes because of the great atmospheric effect that they produce. The final drawing must be sprayed with a fixative.

Charcoal is made from pressed and bound particles of charred wood. It can also be made from carbonized willow or vines, without a binder. Charcoal can be easily applied to the paper as lines or areas of color. Highlights can be created with an eraser or rag. Its effect is austere but expressive. The final product must be sprayed with a fixative.

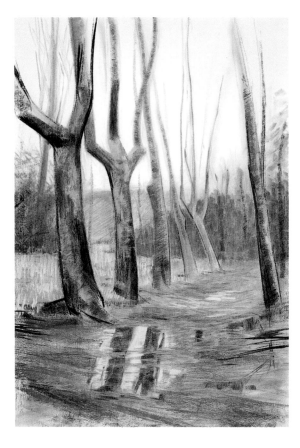

Pencils are graphite bars in wood casings. They are available in different degrees of hardness. Color pencils are made of a mixture of pigments and a binder, and watercolor pencils are soluble in water. They are normally used to draw lines or hatching for larger areas of color. This is a great technique for sketching outdoors, producing fresh, linear results. They do not need to be sprayed with a fixative because they adhere well to the paper's fiber.

Landscapes and Wet Techniques: Watercolors, Acrylics, and Oils

Wet techniques are those that require a diluent or liquid vehicle to spread or to dilute the paint, which always consists of a pigment and a binder. If the binder is soluble in mineral spirits, the procedure is known as oil technique; if soluble in water, a water technique. The first group includes oil paints, varnishes, and diluted waxes, and the second, tempera, acrylic paints, inks, gouache, and frescos. Wet techniques are more versatile than dry techniques and offer a wide range of effects, from impastos to washes, linear-type drawings, airy or flat masses of color, and so on. They are applied either on hard surfaces (wood or walls) or soft (canvas or paper), which almost always require priming. The final work does not need to be sprayed with a fixative because the binder has great adhesive power. Paint can be applied not only with brushes but also with spatulas, sponges, rags, or scrapers, which opens up the creative process even more.

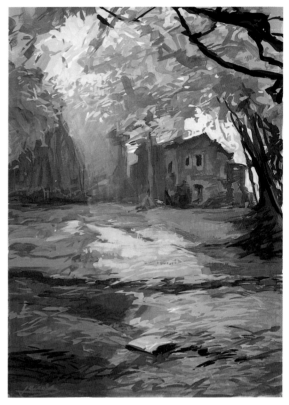

Tempera is a water technique that resembles oil paints and watercolors. It can have more or less covering power depending on the binder. The most common ones are egg tempera, which is very transparent; polymer temperas, commonly known as acrylics; and glue or gouache tempera, like the one in this landscape, with strong covering power and normally used for painting brightly colored, flat surfaces.

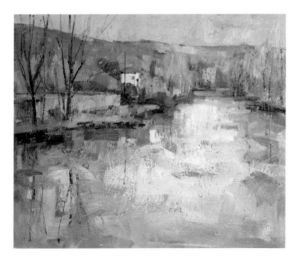

Oil painting is the most versatile medium. Oil paints consist of a mixture of pigment and oil. Because the binder causes this medium to dry slowly, it can be corrected many times to produce combinations of great atmospheric effect. Applied diluted, this medium can create transparent and luminous washes, and when used as a thick paste it produces a three-dimensional effect. Liberally applied brush strokes of different sizes and shapes create a feeling of movement.

Watercolors are one of the most important wet techniques and have a great historical tradition. Watercolor paints are diluted in water and applied to paper. The key feature of this medium is its luminous transparency. Light is represented by the parts of the paper that are left unpainted. Watercolors can be applied as washes or as large areas of layered colors. Inks are a variation of this medium, and most of them can be lightened with bleach.

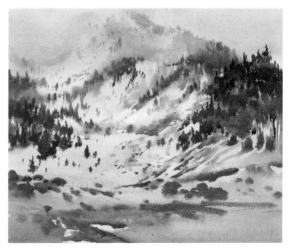

Painting Landscapes Step-by-Step

In the following pages we will present some practical approaches to the genre of landscape painting. Through the nine examples, which cover various themes and techniques, we will review the most important techniques for painting landscapes.

The first half of this book covers all of the technical aspects related to landscape painting: its history, expressive and formal content, types of landscapes, and finally the methods used to represent its elements in terms of form, space, color, and texture. Now, we will apply all those points to nine very different projects, to see the step-by-step evolution of a landscape painting from its planning stages to the final product.

The first three landscapes will be executed using dry techniques. The first one is a landscape drawn with graphite, the second will be done with charcoal, and the third is a poppy field created with colored pencils. The effects of dry techniques more resemble those of a drawing than a painting, because they do not require a diluent. Also, this type of painting is commonly executed with very little color, producing more austere and descriptive results. Many artists choose these mediums for

Selecting a subject and a technique for a landscape painting is an expressive act.

sketches or for preliminary drawings, which will be painted in the studio later, using other more elaborate color and texture techniques.

The following six landscapes have been created using wet techniques. However, the first one, a centered landscape, has been executed with a combination of wet and dry techniques, beginning with acrylics and ending with crayons. The next five examples alternate a water-based medium (watercolors) with an oil-based medium (oil paints). The subjects consist of traditional landscape scenes: fields, mountains, and rocks, linear perspective, water, and the sky. By following the text and the sequence of illustrations for each painting, the reader will be able to acquire a complete and easy-to-follow process for creating a landscape. Selecting a subject and a technique for a landscape painting is an expressive act that helps put us in touch with the true meaning of art.

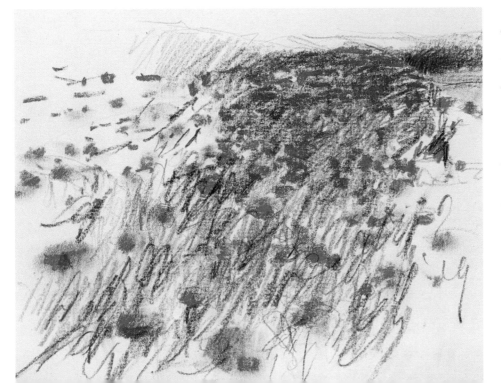

Colored pencils provide immediate results when used for quick sketches outdoors. Exercises like this one, which involves perspective, form, color, and compositional skills, are an excellent introduction to landscape painting before engaging in a more involved project.

Textural Landscapes with Graphite

The texture of some landscapes calls for working with strokes, whether fluid, airy, or impasto. Others may look better if they are drawn with lines. The following landscape by Ramon Massana is one of the most traditional in terms of linear texture: a wheat field. Two bales of hay have been chosen for their volume, to illustrate the cross-hatching method. Although working with lines alone can be very time-consuming, they can produce interesting textures. Different topographic surfaces can be modeled by simply changing the direction of the lines. Van Gogh developed this technique with great mastery in his landscape drawings, which he also painted in color on canvas.

MATERIALS
- Graphite pencils of different hardness
- Smooth, heavy-weight drawing paper

TECHNIQUES USED
- ◆ Initial planning ◆
- ◆ Cross-hatching ◆

In many landscapes, certain elements have a strong sculptural character, like these bales of hay, which form an integral, natural part of the space. The bales offer a rich combination of volume and texture.

1 The drawing begins with an outline of the main elements of the scene. A hard lead (H) graphite pencil is used for this task, making sure not to apply too much pressure, because light lines work best.

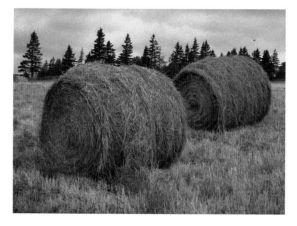

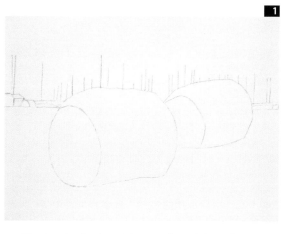

2 The first lines of the texture of the hay bales and the trees in the background are drawn with the same graphite pencil.

3 More texture is applied. This time the forest is completed by intensifying the grays of the background, using a graphite pencil with a softer point (3B), without applying too much pressure.

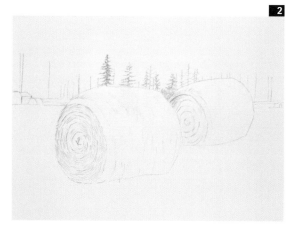

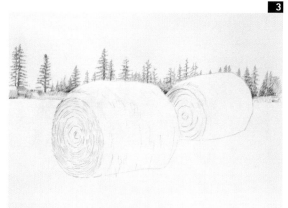

**GRAPHITE PENCILS OF
DIFFERENT HARDNESSES**
Leads come in different types and are
numbered according to a standard code.
The hard leads are labeled with the letter H,
whereas the soft ones are marked with a B.
Availability varies depending on the brand.
One larger selection includes 19 types of leads,
from 9H to 9B. Harder leads make a light gray
impression; soft leads, a darker one. It
is interesting to combine different
types of leads in the same drawing
to produce a range of grays.

4 Continuing with the
application of texture, the
ground and the sky are drawn
next. The size of the line is
changed to create a feeling of
depth. To indicate distance, the
lines are drawn smaller, and the
size is increased for closer areas.

5 Notice how the bales are modeled
with lines, by varying their direction
in such way that they not only mold
themselves to the shape but also define the volume.

6 To increase the feeling of volume, the contrast of the
light must be intensified using softer (5B, 6B) graphite
pencils, pressing on them a little harder to make the lines
darker. The ground now has a little more definition.

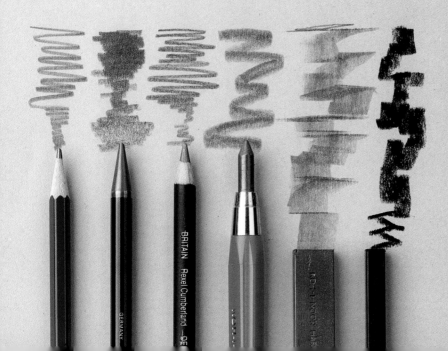

*Graphite is normally
available in sticks, bars, or
pencils, in either soft or hard
lead. Bars are good for
wiping and can create wide
strokes and lines of various
thicknesses.*

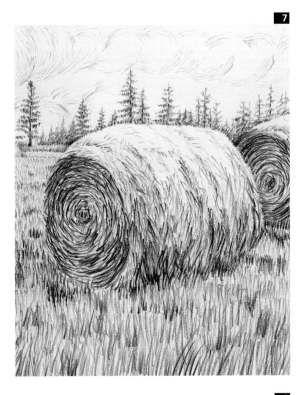

MODELING THE LINE

Lines can be expressive if they are modeled, which can be easy to do with graphite because of the inherent characteristics of the material. Modeling consists of a variation in the intensity, speed, or shape of the lines to create different energy within the same line, depending on how it is drawn.

7 All elements of the landscape have already been defined as far as light, space, and texture. The only task left is to intensify some areas with a darker tone to bring out the effects of the light.

8 Here is the finished drawing. To intensify the dark areas, the lines have been drawn with the softest graphite pencil available (9B). Notice the richness of the lines, which break up the monotony of the ground.

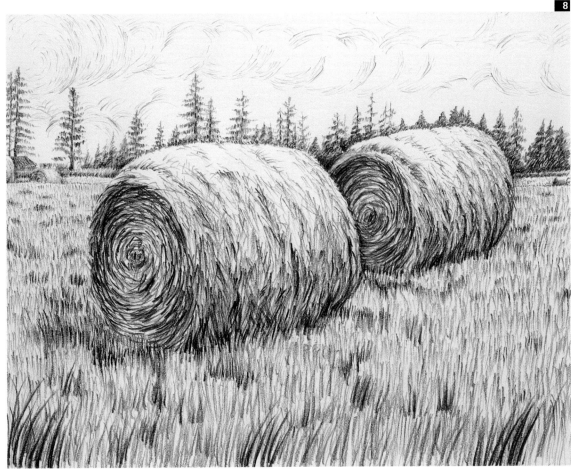

An Enveloping Landscape in Charcoal

The following landscape is a classic scene in a forest. This type of landscape does not have too much spatial depth; instead, it conveys a feeling of denseness. This makes it difficult to direct the eye, and as a result, the distribution of the elements of the painting is harder. The lack of clear structure within the space forces the artist to work with the density of the masses and the play of light and shadow, which in this case complicates matters even more because of the multiple shadows cast on the rugged terrain. In this drawing, Ramon Massana has maximized the use of the possibilities offered by the blending stick, combining the atmospheric effect that this tool is capable of producing with the expressive, vibrant line of the charcoal.

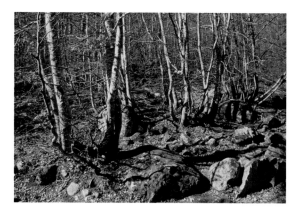

To experiment with the challenges presented by the most extreme light conditions, a forest in autumn has been chosen. The environment appears quite dry, with leaves on the ground, which is both hard and rugged, an aspect that exaggerates the dramatic effect of the light, producing expressive and contrasted shadows.

MATERIALS
- Charcoal in bar form
- Chalks
- Blending stick
- Ingres paper
- Fixative

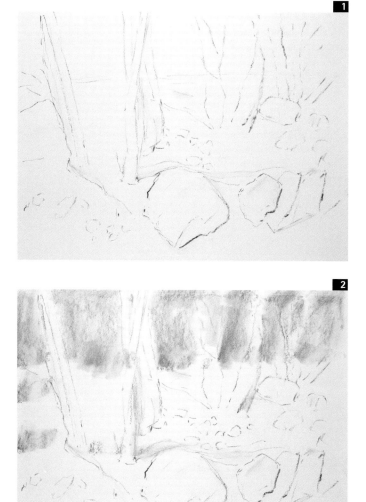

1 The work is laid out with charcoal to indicate out the main contours. Another way to do this would be with areas of color that define the darker parts. Both approaches are valid.

2 To begin creating density in the environment, especially the background, which has many more trees than the closest planes, the areas have been darkened with charcoal that is rubbed to make it penetrate the fiber of the paper.

TECHNIQUES USED
- ◆ Initial planning ◆
- ◆ Drawing ◆
- ◆ Blending ◆
- ◆ Finishing touches ◆
- ◆ Fixative ◆

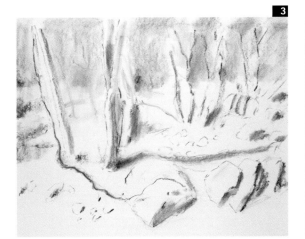

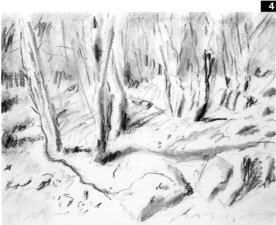

3 In this type of landscape, it is better to treat the scene as a whole where every corner is important rather than working from the background to the foreground. This is why the areas of light and shadow are distributed in a general way.

4 During the first steps, whether the drawing consists of lines or areas of color, the applications do not need to be too precise because their function is to define the distribution of the areas of light and shadow in a general way. These loose lines and color areas will later define every branch, stone, and leaf.

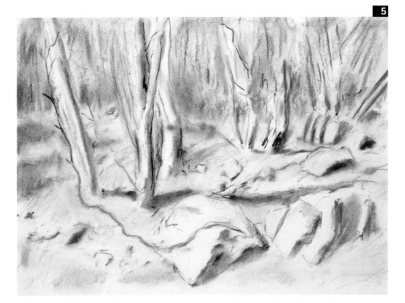

5 The application of tonal variations in this type of landscape requires patience and observation. It is not a good idea to hurry. It is better to draw each section methodically, observing the picture from a distance once in a while to see the whole objectively.

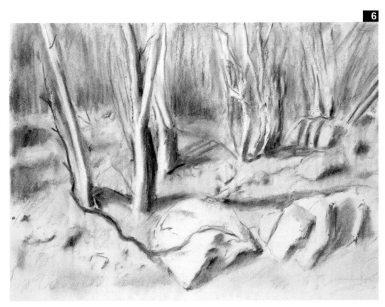

6 The work progresses as the shadows are intensified and the shapes of the elements are defined. At this point, the shapes begin to acquire density to be able to support the emerging elements.

INTENSIFYING THE SHADOWS

The method for darkening some areas with charcoal is to rub them and to apply another layer of color or lines over them. If fixative is sprayed between each layer, the paper becomes more receptive to the charcoal. In any case, natural charcoal is not completely black; therefore, if the black has to be very dark, other materials should be used, like black chalk in bar form.

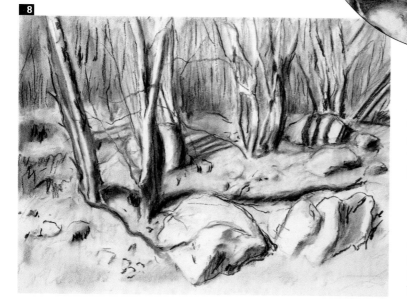

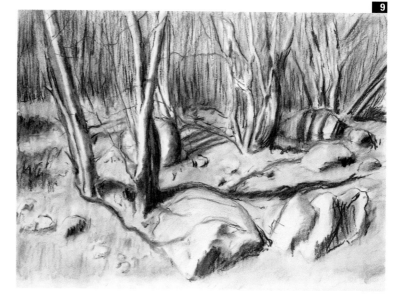

7 More defined branches begin to emerge, which makes sense at this point of the process because the background has already been established. This is the way the rest of the drawing will progress from this point on until it is finished.

8 What before was a simple diffused smudge resembling a rock, now has shape and texture because the lines are more controlled and defined. The same is true for the trees.

9 Tree trunks and branches appear more defined as a result of the chiaroscuro. It is very important to respect the direction of the light, which is why all the tree shadows must be drawn in the same direction.

CHALK

Chalk is made of color pigments mixed with a binder. They are similar to pastels but harder. They can usually be combined with charcoal, although the drawback is chalk cannot be erased as easily as charcoal, which is why it must be applied with a steady hand and without hesitation. The pigment of black chalk is completely black and can be used to darken the dark shades of charcoal. White chalk is used for highlighting and for reflections. The use of sanguine and sepia color chalk is very common because of their natural tones.

Chalk is available in bars and pencil form. Pencils can be sharpened and are cleaner to use, but they are not very good for making wide strokes.

10 *The final result of this landscape has improved in terms of the contrast and richness of tones of the ragged terrain, thanks to the sporadic use of brown, black, and white crayons.*

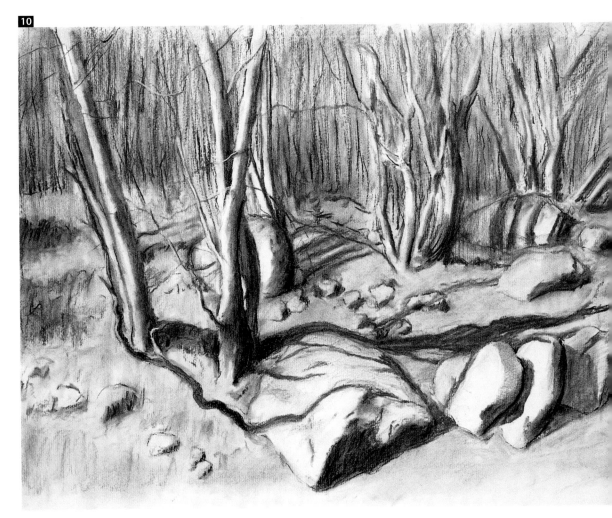

10

A Springtime Sketch

One of the most recurrent themes in the landscape genre is spring because it is a time of the year in which nature displays all its splendor. This is why painting landscapes outdoors is a rewarding activity. A field of wildflowers, like this field of poppies, turns into a true spectacle of light and color. Impressionist artists used this theme over and over again for the vibrant effect created by the combination of two complementary colors like red and green. Josep Asunción executes this exercise with colored pencils because this sketch was done outdoors, and the technique makes it possible to take notes and sketch in drawing pads that are easy to carry in the field.

A scene like this one draws its force from the vibrating contrast of the color of the poppies and the green grass, as well as from the visual effect of the ground, which spreads out like a large rug on which the spectator is situated.

MATERIALS
- Colored pencils
- White paper, with a little bit of texture

Before beginning the final drawing, the artist has made a quick sketch to locate the vanishing point, which has been placed at the upper corner of the drawing, where the most intense colors and darkness are concentrated.

Another preliminary, more elaborate sketch allows the artist to experiment with other colors, like yellow and blue, and with a type of line that has a more expressive feeling.

TECHNIQUES USED
- ◆ Preliminary sketches ◆
- ◆ Blocking in color ◆
- ◆ Rubbing ◆
- ◆ Cross-hatching ◆
- ◆ Final touches ◆

1 The project begins with an outline of the basic fan-shaped composition.

2 A bright red color is used to block in slightly oval shapes

3 The ovals are rubbed with a finger to make them look softer.

4 Next, their centers are colored with a darker, more earthy-looking red. This will give the poppies some volume.

DEFINING FLOWERS BY SHADING

To draw flowers, it is important to observe them closely, especially their shapes. It is not a good idea to draw their outlines, even for those located in the closest planes, because the flowers will appear rigid and lifeless. It is better to practice with lines that, when applied a certain way, will immediately define the type of flower.

5 The poppies, which are already arranged in the field, define the depth of the painting, which is indicated by their size. The smaller the flowers, the farther away they are. Larger flowers suggest proximity.

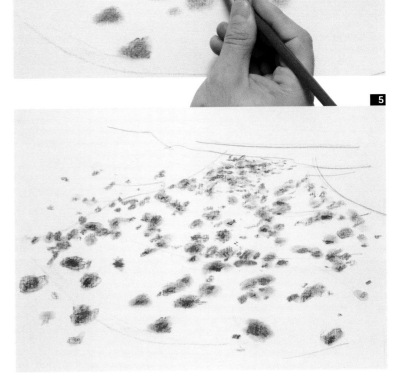

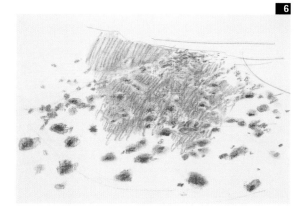

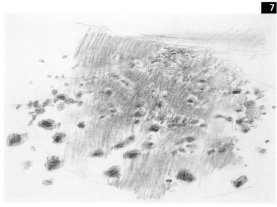

6 Next, we begin to color the field around the flowers with a dark gray-green. The field was painted after the flowers so they would stem from the white background of the paper, making their red color appear brighter.

7 The neutral green is applied over a field with areas of yellow. The added green color will appear more vibrant because the dull color beneath is no longer visible.

8 The artist combines three different greens to give the grass texture.

9 As seen here, the areas of green color have been unevenly distributed. This technique is used to avoid the inherent monotony of fields. The ground will appear richer if different types of green vegetation are introduced.

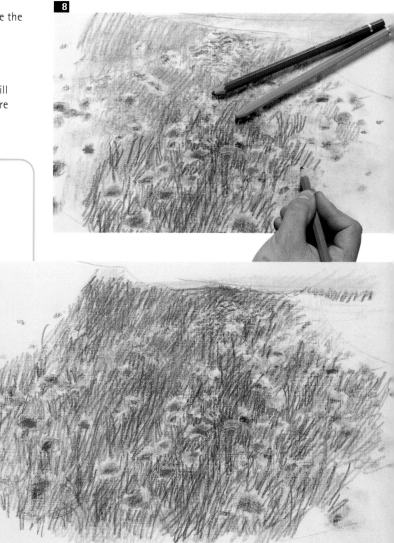

DIFFERENT GREENS

Green is a color that can easily look monotonous. It is one of the most common colors in a landscape, so it is helpful to experiment with it to discover the different colors of green that can be created: bright or dull, blue or yellow, earthy, dark, pastel-like, luminous, and so on. It is a matter of simply combining different types of blues and yellows or mixing them with various earth tones, either on the palette or on the paper itself—that is, if it is a dry technique like this landscape. A combination of different greens makes a picture look less monotonous and predictable.

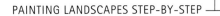

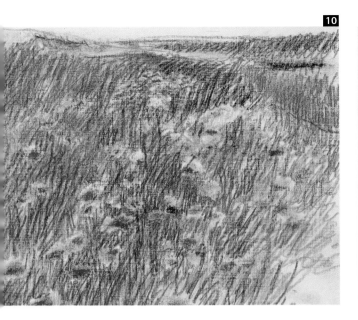

THE ARTIST'S INTERPRETATION
Every landscape painting is subject to interpretation. Because there are many possibilities for framing and points of view, as well as multiple ways of understanding color and form, there is no single way of representing landscapes. Landscapes depicting fields with topography or texture work better if represented with sensations rather than with technical definition of the elements. Sensations are subjective; they are "impressions" that the artist translates on canvas or on paper. Artistic license is not only advisable, but also desirable in this type of landscape.

10 Other colors that seemed to work well in the preliminary sketch are now introduced in the background, like blue and yellow, to hint at the existence of a different landscape with water in the distance.

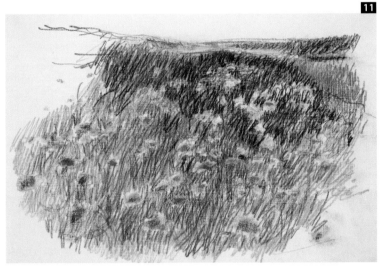

11 When brighter colors are placed in the background, it becomes obvious that to create depth the field of grass should be darker in that area. This will increase the perception of gradations. The linear strokes in the background provide variety and expressiveness.

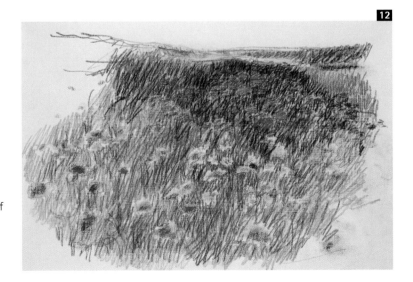

12 For the final stage, the color of the poppies is touched up to intensify the red, which is now more realistic than the pink color of the original drawing.

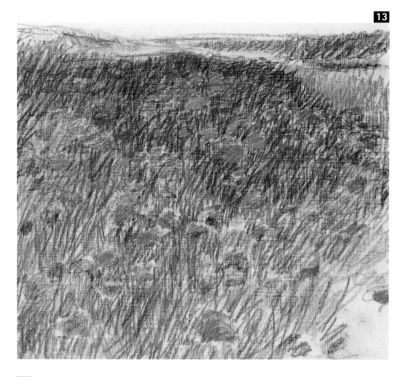

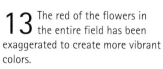

13 The red of the flowers in the entire field has been exaggerated to create more vibrant colors.

14 This is the final drawing of the field of poppies. The artist's own contributions in terms of color and lines in the areas of the water and the horizon give this landscape a personal touch and a strong, lively feeling.

Centered Landscape with Mixed Techniques

Centered landscapes consist of a single element occupying the center stage. They capture the attention of the spectator without producing a feeling of visual isolation; instead, they harmoniously integrate the element with the environment represented. This is true for the landscape that is presented here. The effect is achieved with the contrast between the vertical line of the tree and the horizontal line of mountains in the background that surround it, the solidity and physicality of the tree against the atmosphere and the light. To work on this subject, Josep Asunción has opted for the combination of two very different mediums—acrylics and crayons—and two different techniques—washes and hatching.

The acrylic paint works as the foundation for the lines, which are drawn with crayons.

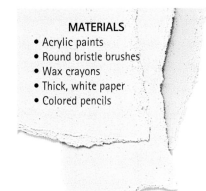

MATERIALS
- Acrylic paints
- Round bristle brushes
- Wax crayons
- Thick, white paper
- Colored pencils

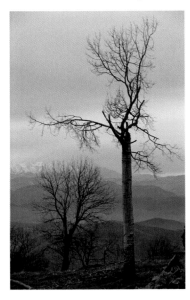

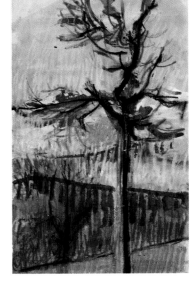

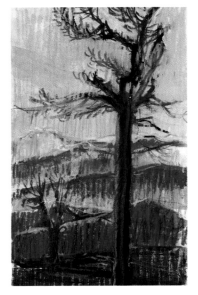

The scene exudes a calm feeling and successfully expresses the magic of the evening light, with its mist and contrasts. It is an orthogonal composition in which the space that surrounds the tree is as important as the tree itself.

These two preliminary sketches will help the author decide on different aspects of the painting, like the color and technique that should be used for the tree and the background.

TECHNIQUES USED
- ◆ Preliminary sketches ◆
- ◆ Preliminary drawing ◆
- ◆ Washes ◆
- ◆ Color hatching ◆

1 The initial layout of the work has been created with colored pencils to outline the main elements of the scene.

2 Three colors have been selected for the background: a warm hue for the light yellow of the sky, graded blues for the mountains in the distance, and earth tones for the foreground.

3 A blue wash has been applied over the yellow sky to make it closer in color to the general tone of the mountains. The ground on the nearest planes has also been darkened to increase the feeling of closeness.

MIST

When the atmosphere is dense, the outlines of the shapes in the landscape appear less defined. Everything appears diffused by the mist, especially the more distant planes. This kind of landscape requires an undefined approach, to be faithful to the atmospheric effect.

4 The tree has been painted with acrylic paints and a brush. Later, lines will be applied with crayon wax over this base to create texture and volume. But these preliminary steps make it possible to lay down a solid background that will serve as the visual foundation for the color lines.

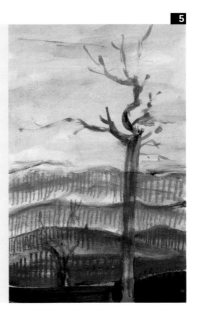

LETTING THE BACKGROUND BREATHE

The background is painted with a base color with the intention of letting it somehow show through the colors applied over it. This is known as "letting the background breathe." The interesting point is that the background colors are different from those applied later, and this is done purposely to achieve a vibrant effect in the areas where the background is visible. Expressionist and Fauvist painters exaggerated this technique by working with complementary colors or with paints in their purest form to create a strong vibrant effect. The contrast between warm and cold colors is the most effective, like that of pinks and blues, earth tones, violets, and so on.

5 The artist begins by applying lines over the acrylic wash, alternating a couple of blue tones, duller for the mountains that are in the distance and brighter for the ones that are nearer.

6 A new mountain peak appears in the background, drawn directly with crayons, as well as notes sketches of other colors that will be repeated later: mauve pink and gray-green.

7 The snowy mountain located in the distance has been reinforced with a combination of color and lines. The sky has been treated with hatching in a warm-gray tone, which also appears in the mountains as an atmospheric effect.

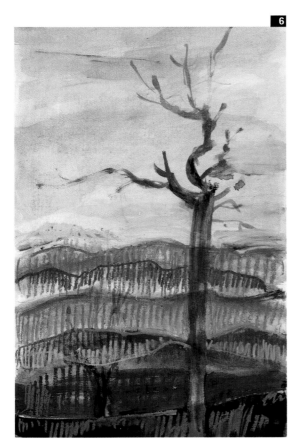

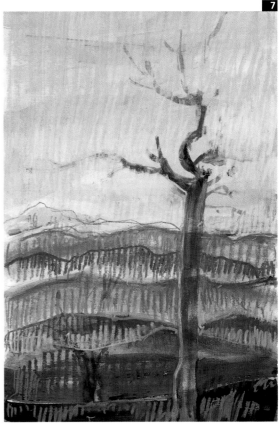

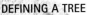

DEFINING A TREE

Trees with foliage are created with strokes of color that combine light and shadow. But the structure or skeleton of dry trees, like the one in this exercise, is drawn with lines. It is very important to draw the lines with the correct angle and modulation for the specific type of branch or leaf, replicating their natural movement.

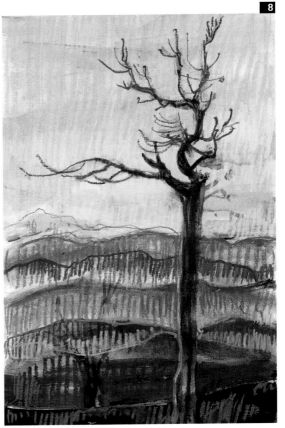

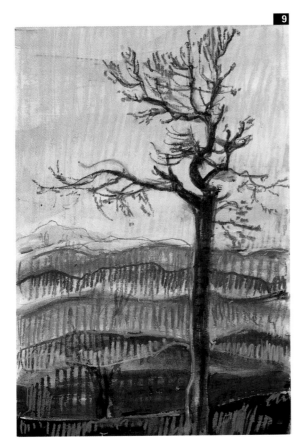

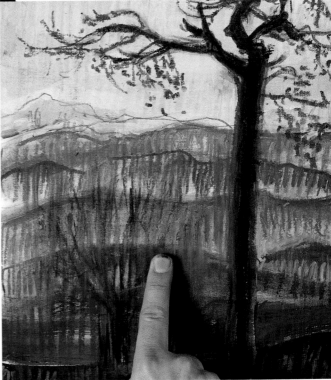

8 To incorporate the tree into the specific atmosphere of the environment, it will be drawn with the same colors that appear around it. This is why the first branches are blue.

9 Next, brown is applied to introduce a variety of tones and to create a greater feeling of volume. Cool tones always convey a feeling of distance, whereas warm ones make things appear closer.

10 The tree trunk has been darkened to increase the contrast against the background, and the tree that is behind it has been rubbed to make it form an integral part of the environment of the painting. Later, this tree will be redefined with lines.

MIXING COLORS WITH THE EYE
When hatching is used, its color is mixed in the eye of the spectator. This phenomenon, so widely used by Impressionist artists, especially those working in a pointillistic style, is effective for creating an atmospheric feeling, because it appears as if color and light are spread over the surface in small particles, creating a feeling of greater density.

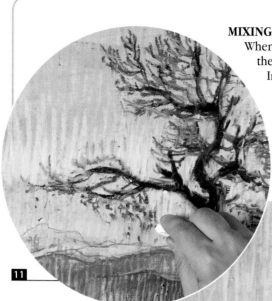

11

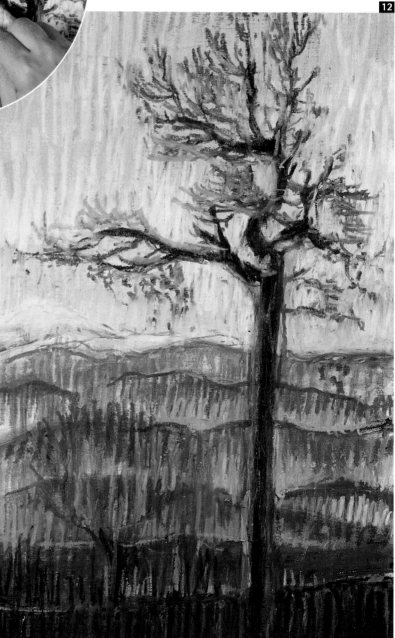

12

11 The color of the sky is adjusted by adding white and more hatching in rosier tones. The lines of the sky begin to mix with those of the tree, enriching one another.

12 This is the finished painting. Notice how the colors that show up at the end act as a chromatic counterpoint, like the blue of the sky and of some of the branches and the pink of the tree that is located behind. The combination of colors is what gives life to this landscape.

Rural Landscape with Oil Paints

The following landscape pays clear tribute to the versatility of oil paints. This medium is ideal for landscapes because of the possibilities that it offers in terms of textures and the brilliance of its colors. The theme is the most classic one for the genre: a field with a house, a forest in the background, a lake, and mountains in the distance. This type of scene has been chosen for the challenges that it presents, including the grassy ground, the house, the foliage on the trees, and the atmospheric effect of the water and the mountains. As can be observed, the artist, Pilar Valeriano, has resolved these aspects with fresh, decisive brush strokes, creating a work that is detailed with effects that are pleasant and natural rather than soft and artificial.

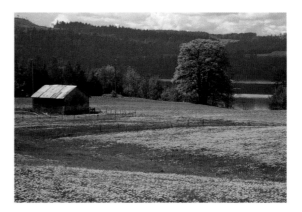

A traditional mountain landscape like this one is a theme that most artists have experimented with at some point in their careers because of its simplicity and the natural feeling of the scenery, the pleasant light, and the vibrant colors that emanate from it.

MATERIALS
- Oil paints
- Round bristle brushes
- Canvas

1 The first sketch is done with loose brush strokes using base tones, over which the paint will be applied later. The first lines place each element in the landscape.

2 The ground is the first feature that should be established in a field like this one. First, the green areas are painted with a bright green color that will be almost yellow in some places. The first layers are applied with paint that is greatly diluted with mineral spirits, almost like a wash.

TECHNIQUES USED

♦ Sketching areas of color with the brush ♦
♦ Painting loosely ♦
♦ Blending ♦

3 To complete the blocking in of the composition, the yellow areas are added, which will set the overall mood of the painting. The three basic colors from which others will stem are lemon yellow, permanent green, and ultramarine blue.

THE FIRST ELEMENTS OF COLOR

The first colors of a landscape can be applied following the tonal or colorist technique. Light is the determining factor in the first case, and a single diluted color is used, depending on whether the areas are illuminated or dark. Then painting continues with the rest of the colors. In the second case, the paint is applied using the general colors for each area, which will be touched up later. This is the method chosen by the artist for this painting.

4 Little by little, each area will continue to be defined by modeling the elements and by adjusting their colors. Here, the forest has been darkened, and the volume of the house has been indicated.

5 The flat look of the previous steps disappears at this point of the process, when the first dark areas are applied to the forest, to the house, and to the background. These are the first steps in representing the effects of the light in the space, giving form to the elements and creating depth.

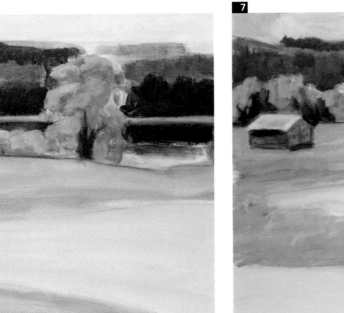

6 Here, the artist continues modeling the trees and the mountains, adding some darker and lighter tones to increase the feeling of three-dimensionality in the background and of volume in the central tree.

7 Next, the sky is painted with a slightly more intense blue, because the previous color had too much light. The clouds are painted at the same time. The first brush strokes indicating the relief and texture of the ground are also introduced.

THE DIRECTION OF THE BRUSH STROKE

Unless the artist wishes to create a hyperrealist painting, the brush stroke can be useful for its expressive movement and the constructive effect on the image. The width of the brush; the charge of paint that it carries, which can range from a glaze to an impasto; and the direction and motion of the artist's hand determine the final result. The brush stroke constructs the painting.

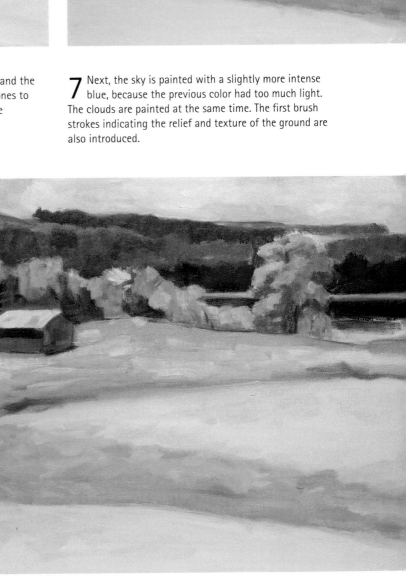

8 The ground takes shape as the yellow and green areas are improved, blending light and loose brush strokes. The perspective of the house has also been improved by increasing the contrast of the light.

9

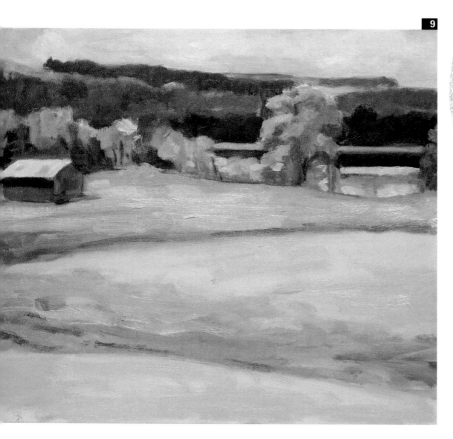

MODELING WITH PAINT
One of the most educational aspects of this painting is the way the modeling of the trees evolves step-by-step—the freedom with which the artist works, creating light and dark areas with rich colors and shapes, using sizes that make the forest appear in color relief.

9 The ground already has texture, and it appears denser thanks to the thick and varied brush strokes. The aspect of the lake has also been changed by creating a greater presence of water, achieved by applying an overall reflection with a single vertical brush stroke.

10 Next, the trees are touched up, giving them more volume and their trunks and the main branches of the central tree more definition, a perfect synthesis of color and lines.

10

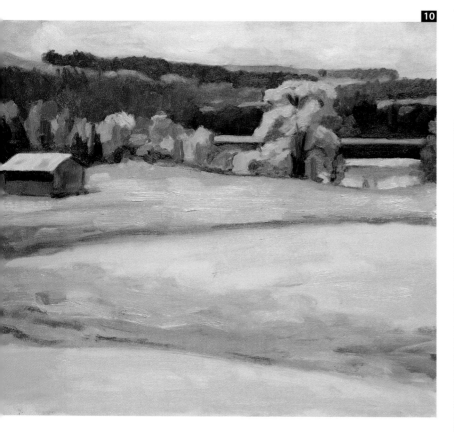

A SIMPLE HARMONIOUS PALETTE
The color harmony of this painting is achieved through a simple harmonious range of colors, also known as a dominant color scheme. It consists of choosing a base color and applying it with its adjacent colors. In this case, the base color is green, which is accompanied by yellows and blues. This type of palette is always harmonious and has a natural look. The richness of the colors of the painting will depend on the number of nuances achieved through mixtures and the effects of the play of light and shadow.

11 For the final stage of the painting, the artist has chosen to intensify the different greens of the grass and to finish the house by completing its roof.

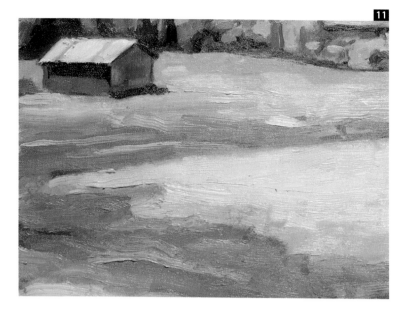

12 The painting is considered finished when the final details, like the fence, are completed. Some areas of light in the clouds and of shadow on the ground will add to the contrast, which enhances visual perception.

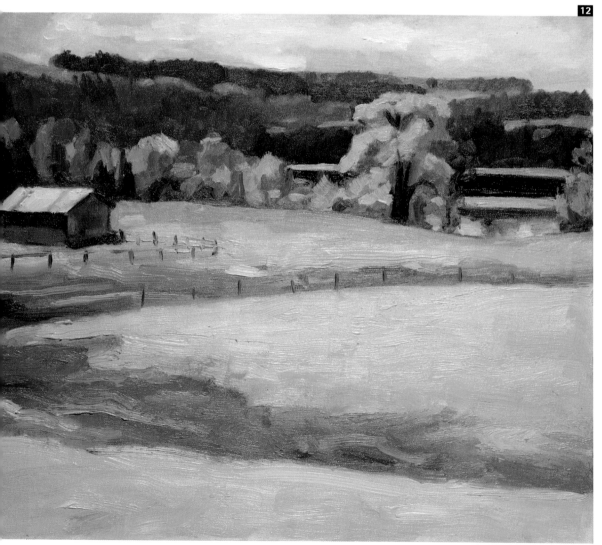

Atmosphere and Depth in a Mountain Landscape

When Leonardo da Vinci developed aerial perspective, it became the basis for representing mountain landscapes. Da Vinci's theory will be applied to the painting that we are about to analyze in this chapter: greater contrast, definition, and warmth for close planes, and less contrast and definition for distant planes, which are painted completely blue. For this landscape, Vicenç Ballestar has chosen oil paints, because this medium makes it possible to apply soft blends for the atmosphere, and impastos for the rugged terrain of the mountains. The artist executes this painting with an incredibly steady hand, without hesitation, and following one of the most classical methods for landscape painting. It involves starting at the top of the painting (the sky) and progressing from the distance to the lowest part (the close planes), in such way that one plane leads to the next visually and technically.

MATERIALS
- Oil paints
- Charcoal
- Canvas prepared with a base color
- Round and flat bristle brushes

The scene that has been chosen is the aerial view of a valley from the top of the mountain. From such an altitude, the eye can see far, so the effect of the atmosphere is evident.

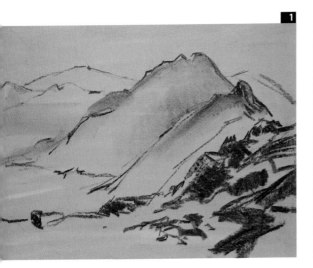

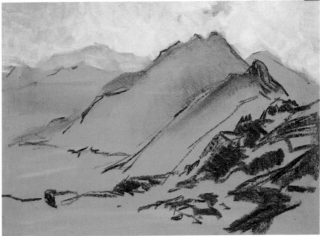

1 This painting is going to be executed on a canvas prepared with a base color. A medium gray has been chosen to aid in the characterization of the landscape, without overdoing the areas of light or shadow. The preliminary elements have been drawn with charcoal to describe the general contours of the mountains and rocks.

2 Because this method consists of defining the top area of the painting and then progressing downward, the sky has been painted first with white, which has been slightly tinted with blue, representing the general light and the misty texture of the clouds.

TECHNIQUES USED

◆ Preliminary drawing ◆
◆ Painting ◆
◆ Blending ◆
◆ Aerial perspective ◆
◆ Progressing through planes ◆
◆ Impasto ◆

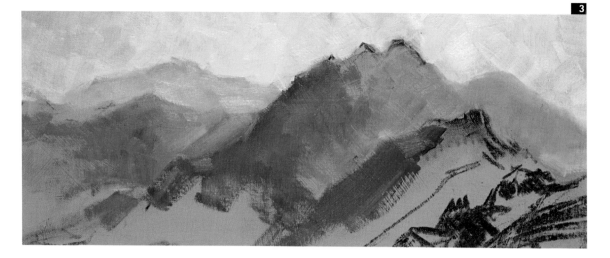

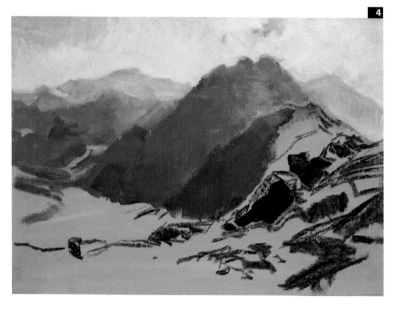

3 The most distant mountains are painted with a blue similar to the color of the sky. In fact, they must blend with the sky in the most distant planes, which is why they should not be painted with a different color blue.

4 The mountains located in the middle distance already appear quite dark because they have greater definition, although no contrast.

5 Next, the work continues with the valley, which will have a blue base color, although it will be slightly gray resulting from the mixture of white and earth tones with the blue color.

THE BLUE COLOR OF THE ATMOSPHERE

There is no rule regarding which blue represents the color of the atmosphere because that depends completely on the effect of the light, which is defined by the time of day, the weather, the location of the landscape, and the season. Many artists use a particular blue as the base for all their landscapes, whether it is cobalt blue, ultramarine, cerulean, or Prussian. That is a personal choice that does not correspond to the visual reality, although it is completely acceptable in art. For this painting, Ballestar has used indigo, cerulean, cobalt, and ultramarine blue combined and mixed with white.

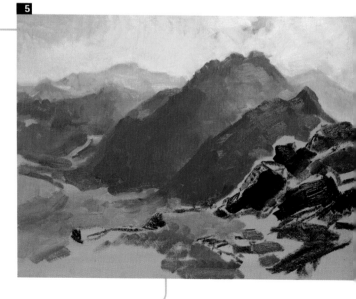

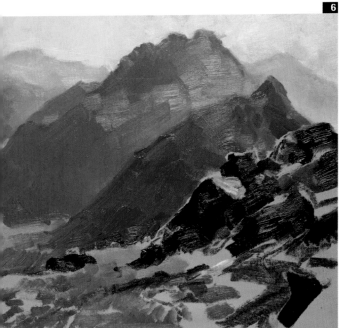

GRADATIONS CREATE DEPTH
One way to create the feeling of depth is to apply gradations, either from dark to light or from light to dark. In principle, dark is more appropriate for representing distance or depth than light, but in landscapes, the opposite is almost always the case. The farthest planes tend to be lighter.

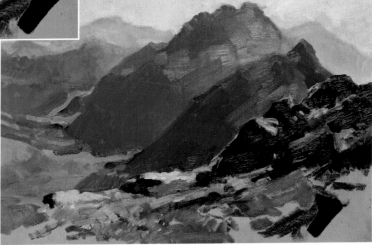

6 A different texture must be used to represent the valley and to make it different from the foreground. To achieve this, the valley is modeled by gently blending the brush strokes.

7 Next, the distance between the valley and the mountain peak is defined with a few touches of intense light at the edges and very pronounced textured brush strokes, without any blending in the foreground of the landscape.

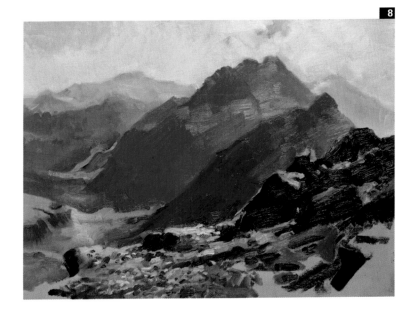

8 The most difficult area to paint in this landscape is the rugged terrain in which the observer is located. To paint it, the brush strokes must be applied directly, with a decisive hand and without overworking. The contrasting light must be strong in this area.

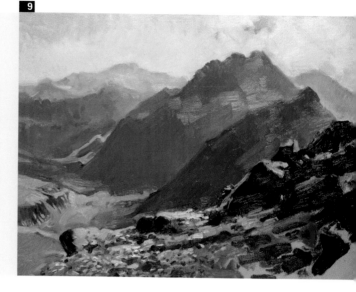

WARM BLUES

Blue is mixed with its complementary to make it darker. In theory, the complement of blue is orange, but just as there are many blues (cobalt, ultramarine, cyan, Prussia, and so on) there are also many oranges. Some can be redder, others more yellow, earth tones, etc. depending on the mixture. If we mix blue with a reddish orange we will get a bluish gray with violet tones; if we mix blue with earth colors, like burnt sienna or Paynes gray, we will get a warm grayish blue. This principle has been applied in this landscape to create the gray of the peaks.

9 The valley has been perfected by modeling its relief with gentle blending and light contrast, and the abrupt terrain of the peak has also been defined. The only thing missing is to complete the lower right corner.

10 Here is the finished painting. Notice how the rocks have been resolved with a radical dark chiaroscuro. Cadmium red and yellow ochre and earth tones have been mixed with the blue of the background.

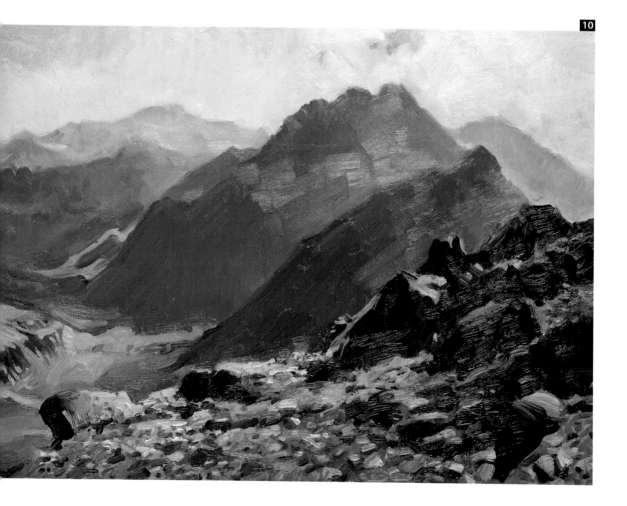

Linear Perspective and Depth in Landscapes

The following example is a landscape where the principles of linear perspective are applied. An appropriate theme has been chosen for the exercise: a tilled field where the seeded rows create a pronounced linear structure. A subject like this can be monotonous if it is not painted with rather free strokes. The author of this work, Ricardo Bellido, has executed the watercolor with great mastery, as proven by the rich chromatic combinations of the details and the general areas of color, even though this is a monochromatic theme. The linear structure with a single vanishing point directs the eye of the spectator toward that point in the horizon, creating a greater feeling of depth.

A tilled field is an attractive theme to be explored because of its spatial depth, but it can be rather monotonous. In this landscape, the tree located in the distance, although not in the horizon, helps create a sense of distance.

MATERIALS
- Watercolors
- Ox hair and synthetic round brushes
- Paper for watercolors
- White crayon

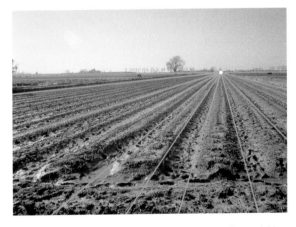

The first step in a linear perspective is to locate the vanishing point and the vanishing lines.

1

1 The work begins with the application of a layer of color, which will serve as foundation. It will be more defined later when the texture of the ground and the details of the rows are added. Notice how this first layer already identifies the vanishing point, without the need for a preliminary pencil outline.

TECHNIQUES USED

- ◆ Study of the perspective ◆
- ◆ Preliminary painting ◆
- ◆ Loose brush strokes ◆

THE HORIZON

Many landscapes present a view of the horizon. When that is the case, the horizon should be the first line on the painting. The point of view of the landscape will vary according to the height of the canvas or paper. It can be centered more on the ground, on the sky, or on both, in a balanced manner. This decision, although it may appear simple, is vital for the success of the composition.

2 After the first layer of color, the artist has identified the horizon, which is located one-third of the way down from the upper edge of the paper. The way the scene has been framed will highlight the texture of the field and will create a long visual path through the tilled rows.

3 The vanishing point where the parallel perspective lines will converge has now been identified. Next, the outside vanishing lines that will frame the rows are drawn.

THE VANISHING LINES

Vanishing lines are typically included in a painting because they form an integral part of the subject that is being represented: roads, railroads, tilled fields, and so on. By painting them, the artist has already begun to define those railroads, roads, or tilled fields. Vanishing lines, therefore, should be drawn with that in mind. For this landscape, the vanishing lines should look rough, with a certain airy quality, to indicate the type of terrain and the color of the earth. In addition, introducing modeled light and shadow contrasts is important to reinforce the idea of three-dimensionality.

4 The elements in the distance are identified with strokes of yellow, green, and earth colors, which hint of trees located far away. The lack of definition in that area of the landscape is important to reinforce the perception of great distance.

5 The vanishing lines are painted from the horizon down. It is better if they do not look too perfect, otherwise the scene could end up looking too cold and artificial. (Keep in mind that for this type of rural landscape some degree of irregularity is desirable.)

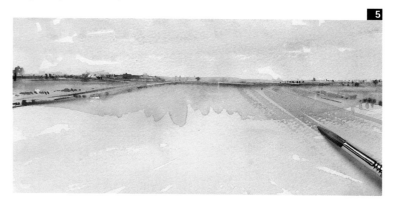

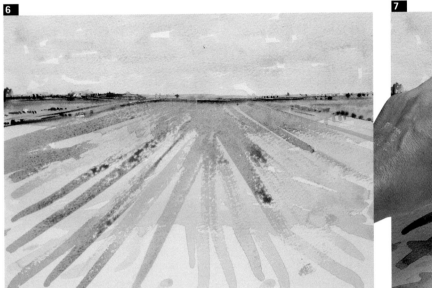

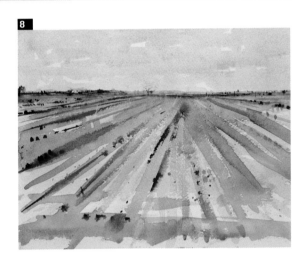

6 The perspective has been completely established. Notice the variety of lines, some wider than others and different in color. Next, texture and relief elements must be applied.

7 Using a crayon, white reserves are applied to indicate areas of light among the rows. Ochre has also been introduced to create yellow touches of warm light, which will show through the final layers of color.

8 Next, the attention is shifted to the tilled rows. They will be painted dark brown to indicate the shadows. Working fast causes dripping, which contributes to the effect of the ground's texture.

9 More colors and darker tones are added little by little to define the ground. The white color of the foundation was still too visible, and the intention was for it to appear only sporadically. The sky is also defined with brighter blues.

TEXTURE
Brush strokes that are too clean and perfect sometimes overpower the textural effects that are more realistic, from the wrinkled, worn, rough, irregular, dirty, or abrupt terrain. Variety is more natural than uniformity. That is why to produce the effect required by a surface like the one described, alternative methods like scratching, masking, spattering, or puddling, must be used in addition to brushwork to introduce an element of surprise and unpredictability.

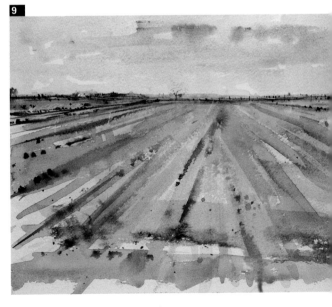

10 Horizontal lines begin to emerge across the vanishing lines, creating a second, freer rhythm, although still connected to the linear structure.

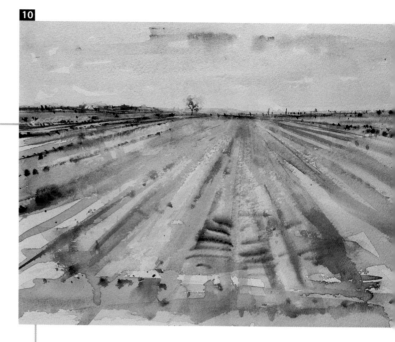

RHYTHM

A sequence of shapes, spaces, or colors creates a feeling of visual rhythm. It is an effect similar to musical rhythm. Repeated strokes of one color are like beating on a drum. It creates a basic structure to which other improvised beats can be added, as long as they fall within the basic rhythm. In this case, the vanishing lines are the basic rhythm and the perpendicular brush strokes and areas of color are the improvisation elements that disrupt the monotony and create a dynamic melody of small peaks and valleys.

11 Finally, the watercolor is finished. Adding more effects would create excessive texture and would make the scene look dense and heavy. That is why the artist has stopped here. The painting is at a point that exudes freshness and spontaneity, which are attractive visually.

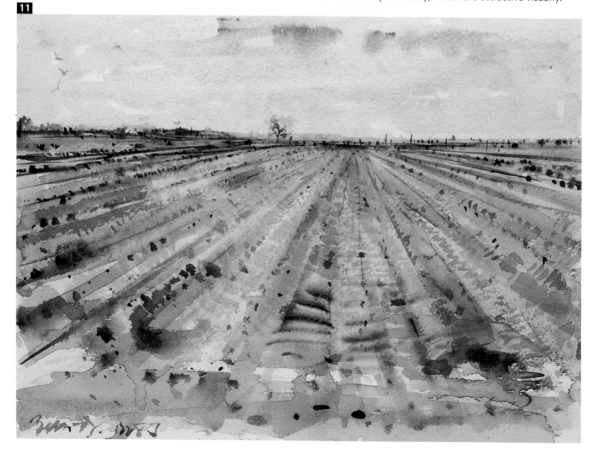

Landscape with a River in Watercolors

Although an entire book could be devoted to water-related themes in landscapes, we had to include in this book at least one landscape that, although not qualifying as a marine painting, has water as the main protagonist. The watercolor painting presented below is an attractive river landscape because of the small island that has formed in it, and because of its trees, which cast their reflection in the water. Mercedes Gaspar is the author of this beautiful watercolor that has been created freely and with natural colors. Watercolors are not, as it is commonly believed, the most difficult technique, because they do allow limited corrections to color and light if made quickly. Although individual lines can be corrected, the overall structure and composition are irreversible.

The beauty of this scene is in the contrast between the exuberant vegetation of the island and the smooth texture of the water that surrounds it. The cold atmosphere and the soft light create a pleasant unity.

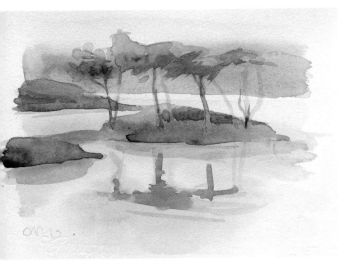

MATERIALS

- Pencil
- Watercolors
- Ox hair and synthetic round brushes
- Paper for watercolors

Before starting with the painting, the artist has created a simple sketch of the landscape to evaluate the range of colors and to become familiar with the subject. After a sketch like this, the artist can engage in the final execution with more confidence.

1 The preliminary drawing is done in pencil without applying too much pressure so that the paper's fiber is not damaged. This initial sketch includes the outlines of the main areas of the watercolor.

TECHNIQUES USED

- ◆ Color sketch ◆
- ◆ Preliminary drawing ◆
- ◆ Wash ◆
- ◆ Painting ◆
- ◆ Lightening ◆

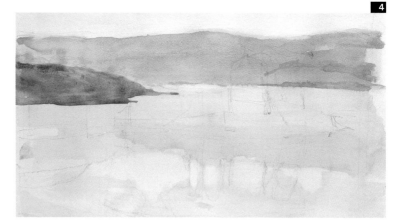

2 The mountains in the background are painted first with a general green and blue wash. An even-looking background, with faint outlines, promotes a feeling of distance.

3 Darker green brush strokes are applied over the background located in the right-hand corner, to create a certain three-dimensional feeling and the overall color of the water, which is violet-gray.

4 The left bank of the river has been represented with a simple, darker, earthy green tone. This difference in tonal value already suggests great distance with respect to the background, indicating that the river continues behind this small piece of protruding land. Also, reflections of light have been created in the water by applying the moistened brush over the color of the foundation while it is still wet.

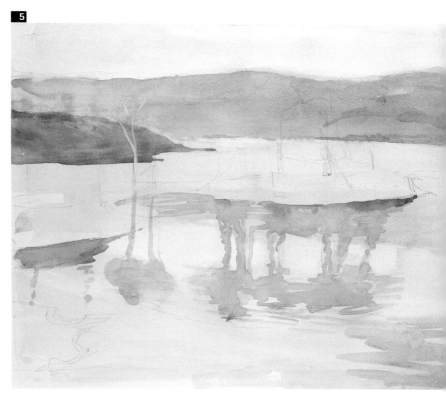

5 The tree trunk is created by extracting the color from the wet base with the wet brush. The first reflections in the water have also been painted, with mauve color.

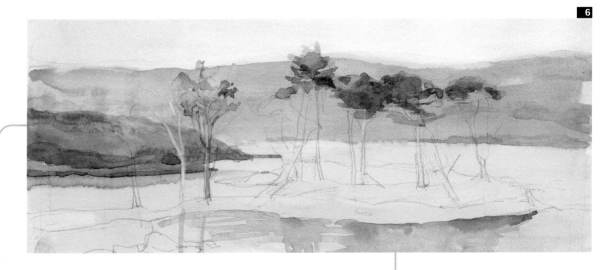

6

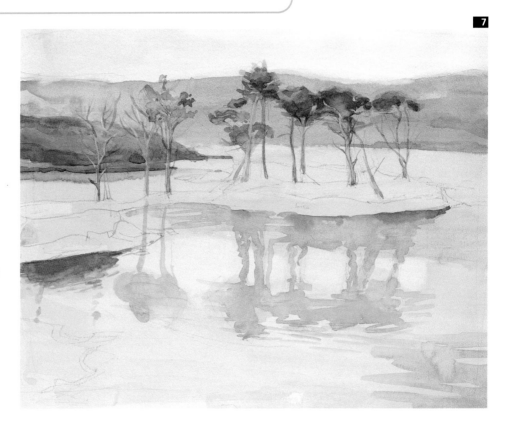

7

COMBINING BLOCKS OF COLOR AND LINES

The successful combination of blocks of color and lines can construct any image, regardless of its complexity. The trees of this small island require this type of combination, because their trunks and branches are as important as the foliage. The key to successful drawing and painting is good observation skills, looking for the movement that describes those branches in space and in the volume occupied by the foliage. Visualizing those movements with hand motions, as if it were a dance, is a good exercise before painting them.

6 At this stage of the work, the artist has decided to rearrange the composition by drawing the trees and the outline of the island over the watercolors with a higher definition. The pencil lines will be erased later, but now they serve as a guide.

7 The trees are perfectly defined with accurate brush strokes that describe the movement of the trunks, the branches, and the foliage.

8 The vegetation is painted with several tones of green to represent the ground that covers the surface of the island. Some light and shadow contrasts are already visible in response to the development of the landscape.

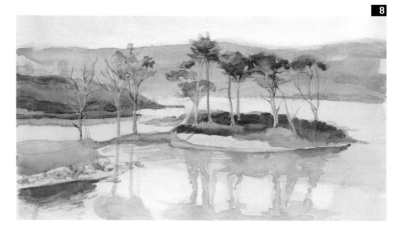

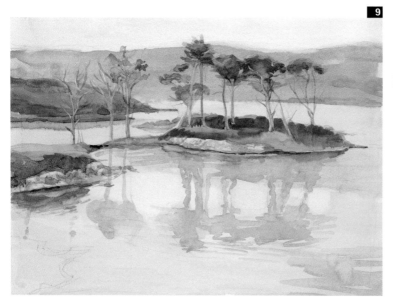

REFLECTIONS
Water acts as a mirror reflecting the objects that are around it and altering their shapes as a result of its movement. In this river, the water flows very calmly; therefore, a simple zigzag movement around the shapes of the silhouettes will be sufficient to represent it. A few additional horizontal lines will indicate the movement of the water.

9 Finally, attention is focused on the island, creating highlights in the reflection of the water according to the method applied before.

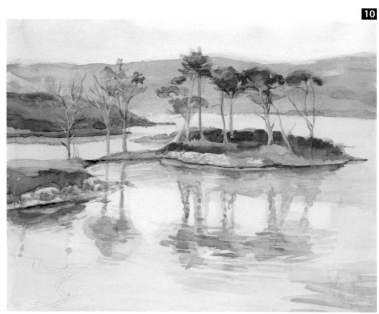

10 A few strokes of dark mauve color over the reflections of the trees create an effect of double reflection, as if the outline of the silhouette started to fade. This is a very good technique for conveying a feeling of coolness to the water.

11

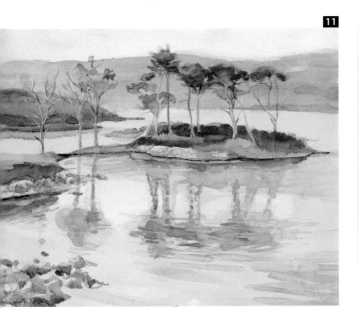

ADJACENT
COMPLEMENTARY COLORS

This watercolor has a chromatic harmony based on two adjacent complementary colors, green and violet, which at the same time are two secondary colors. This combination, along with green and orange, also secondary and adjacent complementary colors, is harmonic and natural, because they can often be found in nature at different times of the day. The Impressionist painters created great landscapes with this range of colors.

11 To leave the final image free from unnecessary lines, the entire pencil drawing of the trees and the island has been erased, and the lower edge of the river has been painted with small brush strokes of mauve.

12 Here is the finished watercolor, with all of its elements well defined by loose brush strokes contained in the shapes. The chosen color range expresses the personality of the artist.

12

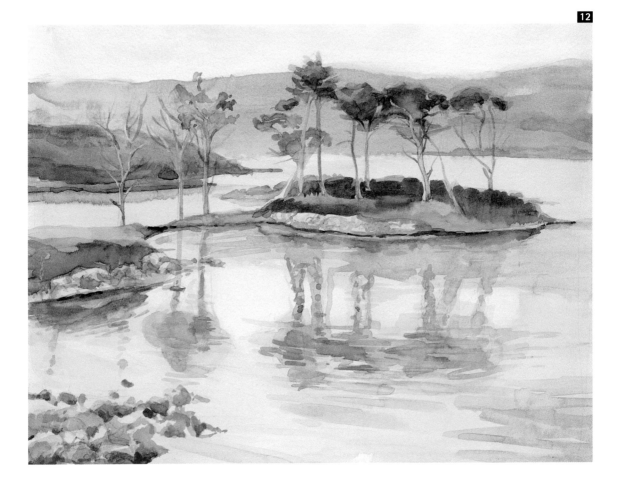

Cloudy Sky with Oil Paints

To conclude, we are going to explain how to paint a landscape with the sky as its main feature. Skyscapes are a type of landscape that have aspects in common with other subjects. First, we will see how this skyscape has a spatial perspective that can be applied either to the sky or to the land. If the image is inverted, the diminishing size of the clouds and their definition in the horizon can be appreciated. Second, the clouds have a distinctively spongy texture that must be resolved creatively, and third, there is the question of how to model the volumes, treating them as if they were a forest, but with a different surface and color palette. Vicenç Ballestar has developed this final exercise with great success by creating expressive, realistic clouds and giving the painting a personal touch with the vibrant red color of the land.

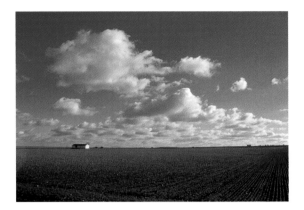

Skies are changing features. Sometimes they look red with exaggerated contrasts of light; other times they appear misty gray or bright blue, like the one in this landscape. The play of volumes in these clouds creates a feeling of open space, greater than if it were the sky in a clear day.

1

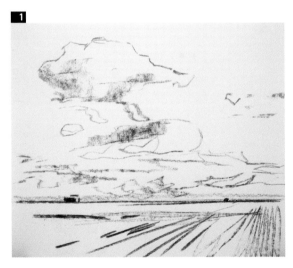

MATERIALS
- Oil paints
- Charcoal
- Canvas
- Round bristle brushes

2

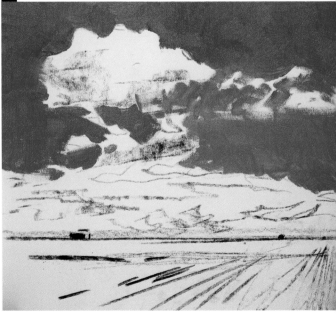

1 The painting is planned by laying out the composition with charcoal. To do this, the horizon is established first, then the vanishing lines of the ground and the main volumes of the sky are arranged.

2 The next step is to determine the blue color that corresponds to this clear day. The artist has used cobalt blue as the base color, to which ultramarine or cerulean blue, depending on the area of the sky, has been added.

TECHNIQUES USED
- ◆ Preliminary drawing ◆
- ◆ Painting ◆
- ◆ Blending ◆
- ◆ Modeling ◆
- ◆ Impasto ◆

MODELING THE CLOUDS

Painting a cloud is like painting any other object, except that its outlines are imprecise, especially those shapes inside of it. Therefore, we must observe where the light comes from—in other words, the position of the sun—because this will be the side of the cloud that will reflect the light, which will be white if it is daylight, yellow at sunrise, or golden, orange, violet, or red at sunset. The other side of the cloud will be dark, in the shadow, although streams of light may emerge from between the shadows because a cloud is not a solid, opaque body but a cottonlike translucent mass.

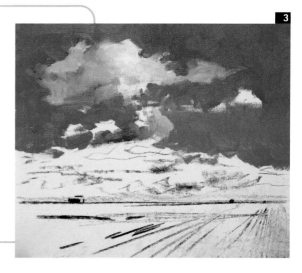

3 Before moving down to the lower planes, it is necessary to begin modeling the larger clouds, which present a complex combination of light and shadow.

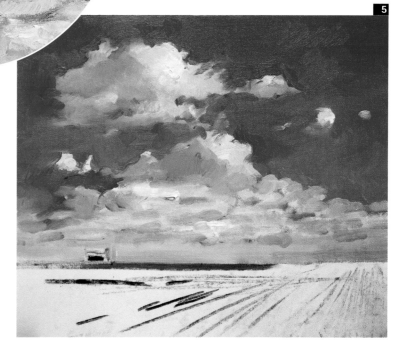

4 The first areas of color that begin to shape the chiaroscuro are painted with the same blue color, with more ultramarine blue and tinted gray with earth tones and white. The brush strokes are loose and thick to allow blending, which will soften the volumes.

5 Now the sky has been laid out completely. Some light values in the larger cloud have been touched up, and the color of the horizon has been established with the little house in the distance. Because the paint has been thickly applied, the colors can be mixed on the canvas itself and not on the palette. This creates a texture similar to the cottonlike appearance of the clouds.

6 Because the general color of the fields is earthy orange, the artist has decided to exaggerate that warm feature by creating a red color with cadmium orange, carmine, and burnt sienna. This red will counterbalance the color of the sky, making it vibrate intensely.

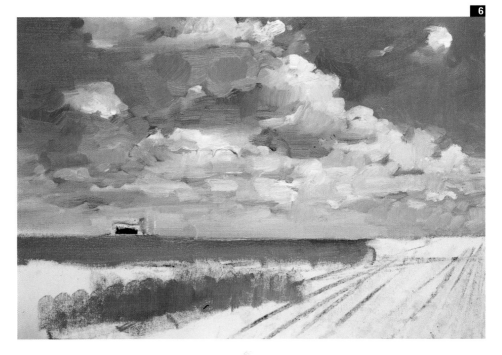

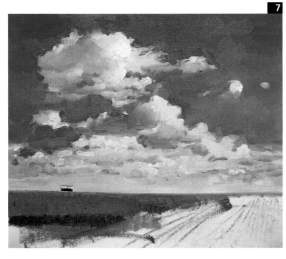

7 As the red extends over the canvas, it is necessary to touch up some of the clouds by adding blue between them to compensate for the brightness of the red. The foreground has been painted in a dark green color.

CONTRAST BETWEEN SKY AND LAND
To achieve greater color brilliancy for the sky, artists usually create stronger contrasts than the sky really presents. If the sky is yellow, they apply purple tones; if it is intense blue, orange; if it is orange, green; and so on. That contrast engages the different natures of the two larger planes, the sky and the earth, in a harmonious dialogue.

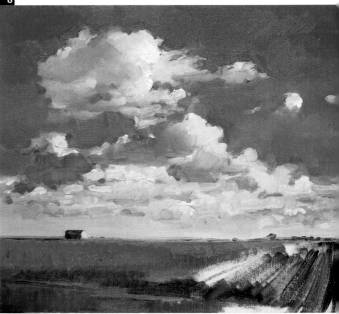

8 The green for the ground has been created by mixing permanent green with olive green and, in someplaces, with earth tones and blue for the darker tones, which isolate the red because blue is its complementary color and because of the degree of luminosity.

9

THE SUCCESSFUL USE OF COLOR

Lets imagine this painting with other colors—for example, with the ground painted bright green, light orange, or dark brown—three possibilities that do not seem so outrageous. In the first case scenario, the blue color would appear less vibrant because of the presence of green, which has blue in its composition and will not produce any contrast. In the second case, orange is as important as blue, because they are complementary colors and it also is bright. And in the third, blue would vibrate a lot because of light, not color. The orange-red, slightly darkened, makes the blue vibrate because of the complementary factor and its luminosity.

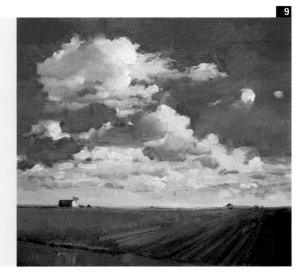

9 The color composition of the painting is practically finished. The dark areas at the bottom make the clouds appear brighter, and their gray tone is the reason the saturated red and the blue colors are so vibrant.

10 To complete the work, the linear perspective of the tilled field is drawn, which interestingly enough forms an angle that converges in the horizon with the inclination of the two clouds—a coincidence that exaggerates the effect of the perspective.

10

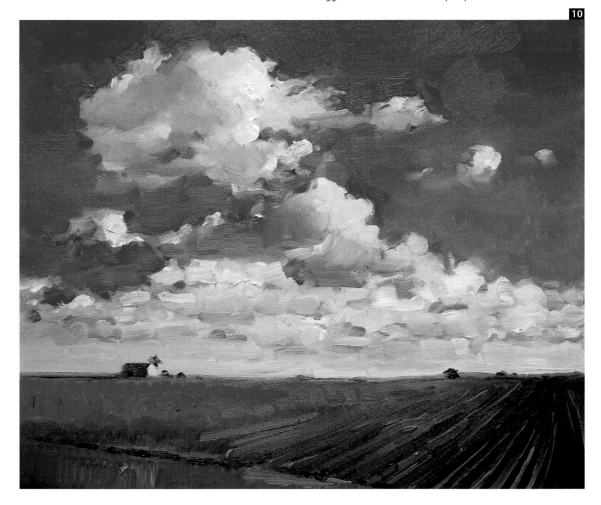

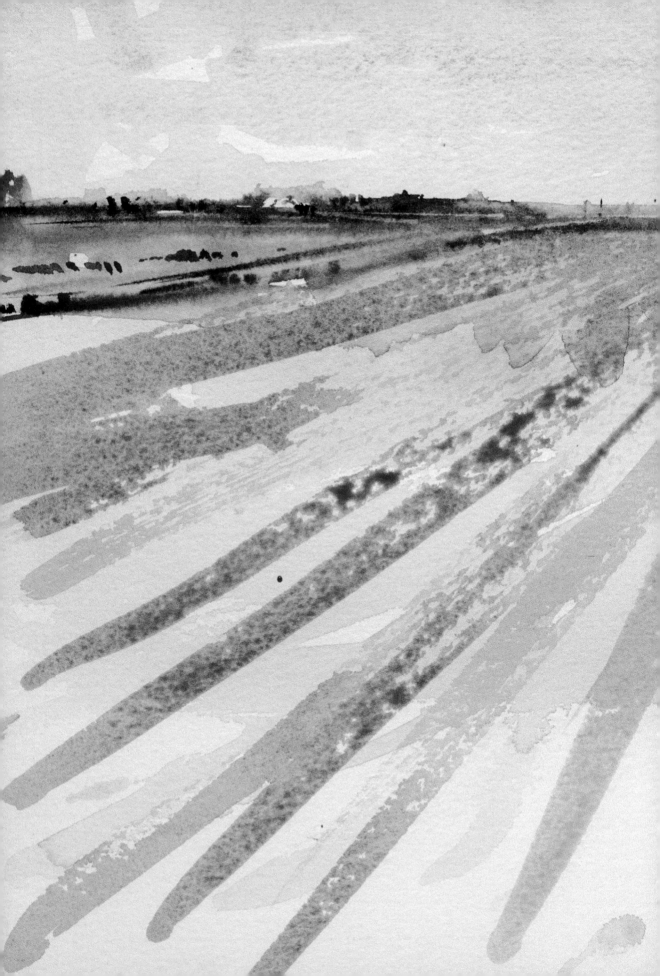